DRAW FASHION NOW

TECHNIQUES, INSPIRATION, AND IDEAS FOR ILLUSTRATING AND IMAGINING YOUR DESIGNS

DANIELLE MEDER

CONTENTS

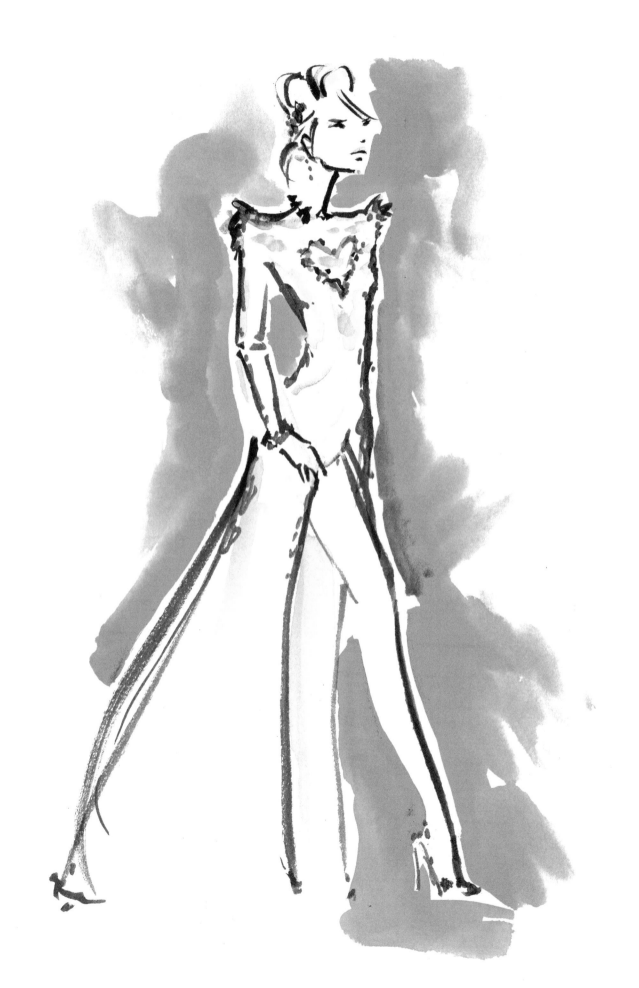

The intention of this book is to demystify the process of drawing fashion figures. The format is based on how I learned, and how I teach. When I teach classes on fashion illustration, I walk my students through the process step by step, explaining the principles as I go. The students follow along with me, and by the end of the class, we all have a finished illustration.

That's what you can do with this book. After each of the tutorials there is a template you can use, so you can draw along with me, too.

Don't feel you must follow the instructions too slavishly. I encourage you to choose your own details, create your own designs, choose your own colors. Use the drafts as templates for your own creative ideas. The drawings I've broken down into steps are simply examples of what is possible; everything else is up to you.

As a young person, I struggled with illustration until I committed to learning technique. I took out the best fashion illustration texts from the library and diligently followed the instructions. That time ended up being well spent, as those skills I learned allowed me to pursue fashion illustration as a career. I owe tremendous gratitude to the creative generosity of Steven Stipelman, Bina Abling, and Bil Donovan for creating fashion illustration texts of the highest quality, which I wholeheartedly recommend.

Given the opportunity to create a book on how to illustrate fashion, I have the responsibility to build upon the great information that is already available. The unique value I feel most capable of delivering is to reflect the time I am writing in. Starting my career in the early 2000s means I am among the last cohort of fashion illustrators trained exclusively in analog techniques, coming of age and starting my career at the same time as the digital media world became mainstream. By necessity, I am always going back and forth between the digital and analog worlds, which informs my style, my identity, and the instructions in this book.

The great texts I worked with as a fashion student were written in the 1980s and '90s, by illustrators whose decades-long careers and styles were established in the 1960s and '70s. Since then, fashion models have changed, and the way they walk the runway has changed as well. The emergence of street style and the spectacle of the red carpet are now just as important as runway shows, and they have their own style conventions and poses. By using the three most important theaters of twenty-first-century fashion as reference, I aim to reflect the attitudes of my own time and help aspiring fashion illustrators develop skills to reflect theirs.

Acknowledgments

Thank you to my editor, Joy Aquilino, for giving me the opportunity to create my first book, a career milestone I never expected would happen so soon. It's a dream come true.

Thank you to my mom and dad, for giving me everything I needed to pursue a creative career—infinite love and encouragement, the values of practice and thrift, and the core belief that I can learn anything on my own and do whatever I want.

Thank you to all of my clients, whose tangible support makes everything I do possible.

Thank you to all of my teachers and professors, especially Katherine Bosnitch, whose meticulous instructional style was so effective and informs my own method.

Thank you to Ray Comiso, for the gift of my first studio and for being the most influential example of hard work, good tools, quality materials, and wild dreams.

Thank you to all the friends I have made on the Internet, who made me realize I'm not alone in my obsessions.

1

DRAFTING BASICS

Creating a fashion illustration that looks easy and elegant is not as simple as it seems. Even drawings that appear spontaneous adhere to consistent principles. This chapter breaks down the elements of the fashion figure into shapes and lines, focusing on proportions.

The proportions in this book use fashion models as reference. Most humans are seven heads tall, but fashion models are often eight heads tall. Fashion is idealistic and exclusionary. All the figures in this book reflect contemporary cultural attitudes toward physical beauty. Fashion illustration does not address the incredible variety of the human form. For that worthy pursuit, practice life drawing and seek out classical fine art instruction.

Historically, a very exaggerated figure has been popular in fashion illustration—nine heads or even higher. Usually the legs would be unnaturally lengthened relative to the torso. However, on reviewing available instruction, I felt that these extreme figures appear dated. In my own work, I prefer a more balanced figure, allowing the clothing the figures wear to be somewhat more faithful to reality.

By using the relatively realistic eight-head figure, I hope that the instructions in this book will provide a solid technical foundation that will stand the test of time. Fashion will always change and future fashion illustrators will modify the rules to suit the tastes of the day, but proportions based on real models will never go out of style.

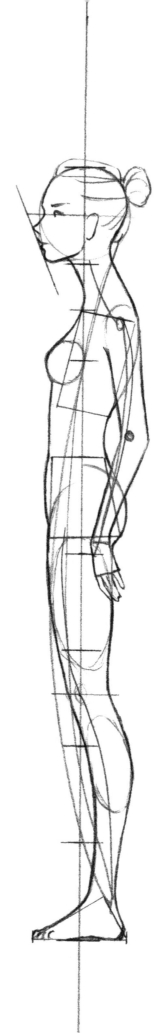

STUDIO SETUP

Fashion illustration requires only a minimal amount of materials and space, and it can be done almost anywhere. What follows is a list of equipment and materials to set up a simple working studio. This will allow you to work through the first section of the book and all of the drafting tutorials.

Here is a picture of the studio in which I created this book. Having a great space to work in is incredibly important for making productivity pleasurable. I love going to my studio every morning.

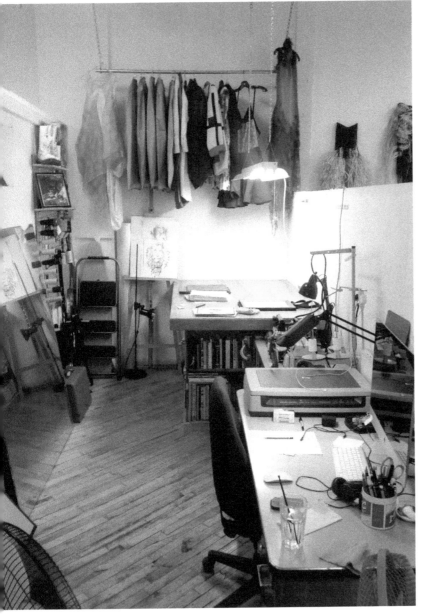

Furniture and Equipment

Any sturdy table or desk will do. Have a comfortable chair at the correct height, so your feet are flat on the floor. Many artists like to work on an angled surface because it reduces distortion and back strain, especially if you are working on larger drawings. For smaller drawings at the scale of this book, working on a horizontal surface is fine, too.

Light is very important. If possible, work in a room with a lot of natural light. No matter what, a bright task light will optimize your ability to see—very important for illustration! Any desk lamp will do, or you can get a specialized task lamp. Ideally, the bulb should be "full spectrum" so colors will appear accurate. Make sure the lamp is placed opposite the hand you hold your pencil in, so you don't shadow your own work. If you're right-handed, the lamp will be on your left, and if you're left-handed, the lamp will be on your right.

Almost all of the tutorials in this book require tracing. I recommend translucent layout paper for drafting, which is thin enough to trace without backlighting. Some people prefer to use nearly transparent tracing paper.

Once you're ready to do the final illustration you'll often be tracing onto thicker, opaque paper, which will require the use of a light box.

LED light boxes that are now available in art supply stores are compact, bright, and portable. The bulkier, old type of fluorescent light boxes will work, too.

You can even improvise your own light box. Place a light bulb on a table and stack books and magazines around it to allow you to place a sheet of clear or frosted Plexiglass or glass over the top of the bulb.

If none of these options is available, you could also use a computer monitor or flat television, with the brightness turned up. Use removable tape to affix your original draft and the paper you're tracing to the surface of the monitor. Make sure not to press your pencil too hard so you don't damage the display, especially if you're using a laptop screen.

If nothing else is available, during daylight hours a window can also work for tracing.

On Drafting

A draft is not a final illustration. I encourage you to make a mess of your drafts, the messier the better, and make lots and lots of them. I've tidied mine up for instructional purposes so they won't be confusing, but I assure you that my drafts are never this precious. Beneath every gorgeous fashion illustration there are multiple discarded drafts, smudged, creased, sometimes cut up and taped back together. Some of the drawings in this book went through dozens of iterations. No one is going to see the drafts anyway, so please feel free to make as many mistakes as you need to. You have to do all the bad drawings to get to the good drawings, trust me!

Materials

This is what you'll need to do all of the drafting tutorials in this book:
Pencils, HB and 2B
Pencil sharpener
Kneaded eraser and/or vinyl eraser
Translucent layout paper and/or tracing paper
Ruler (in inches or cm)

DRAFTING THE FEMALE, FRONT VIEW

Welcome to your first draft! This is a female figure from the front, standing in bare feet, not posing, so she is symmetrical. This draft will show you how to build a proportional framework for your figure. You can use the completed draft as a reference image for proportions or as a template for technical drawings.

MATERIALS

2B pencil
Pencil sharpener
Kneaded eraser
Ruler
Translucent layout paper or tracing paper

STEP 1

Draw a vertical line through the center of your page. Place the figure in the center of the page, drawing two marks 8" (20 cm) apart. Leave margins at the top and the bottom of the figure, to give your drawing space.

Divide the space between the top and bottom marks into eight equal 1" (2.5 cm) sections. Draw a horizontal line at the lowest mark for the floor.

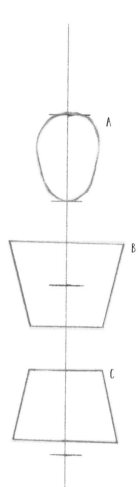

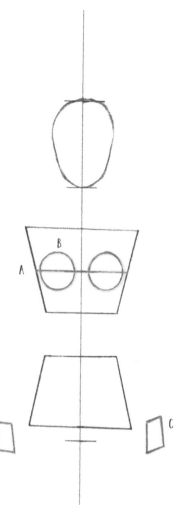

STEP 2

A In the top section, centered on the vertical line, draw an egg shape for the head, with the pointed end at the bottom.

B Centered on the third mark from the top, draw a trapezoid for the rib cage and shoulders. Make it wider at the top than the bottom.

C In the fourth section from the top, draw another trapezoid for the hips. Make it wider at the bottom than at the top.

STEP 3

A Draw a horizontal line at the third mark from the top to guide breast placement.

B Equidistant from the center, draw two circles on that line for the breasts.

C On either side of the hips, draw two small trapezoids for the backs of the hands.

D At the bottom horizontal line, draw two small trapezoids on either side of the center for the front view of the feet. The bottom of these shapes is wider than the top.

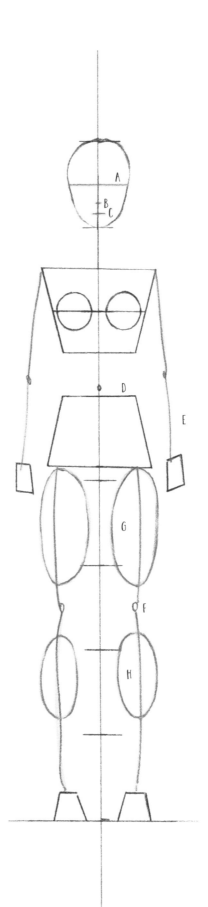

STEP 4

A To guide eye placement, draw a horizon-
tal line through the center of the head.

B Halfway between the eye line and the
chin, mark the tip of the nose.

C Halfway between the nose and the chin,
mark the opening of the mouth.

D Just above the fourth mark from the
top, draw a dot for the navel. At the
same level, between the hands and
the shoulders, draw two small marks
for the elbows.

E Connect the shoulders to the elbows, and
the elbows to the wrists.

F Halfway between the hips and the ankles,
draw two marks for the knees.

G Connect the hips to the knees. Along
these lines, draw two large ovals for
the thighs.

H Connect the knees to the ankles. Along
these lines, draw smaller ovals close to
the knees for the calves.

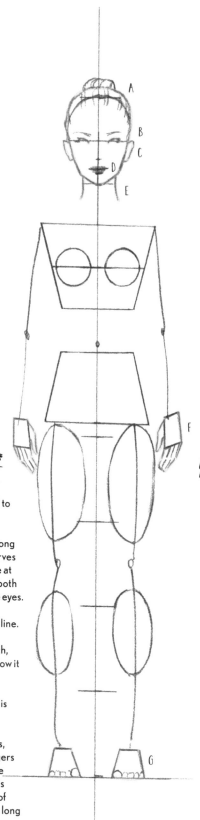

STEP 5

A Extend the hair above the skull to show volume.

B On either side of the center, along the eye line, draw two small curves for the eyelids. There should be at least one eye's width between both eyes. Draw eyebrows above the eyes.

C The ears are just under the eye line.

D Widen the opening of the mouth, and then draw a small mark below it to suggest the lower lip.

E Draw the sides of the neck so it is narrower than the jaw.

F On the inside edge of the hands, draw the thumbs. Draw the fingers extending below the back of the hand. The length of the fingers is equal to the length of the back of the hand, and the entire hand is long enough to cover the face.

G Draw five toes on each foot, with the largest toes by the center line.

STEP 6

Using the framework of lines and shapes as a guide, flesh out the figure's body using softly curving strokes.

The limbs narrow slightly at the elbows and knees, wrists and ankles.

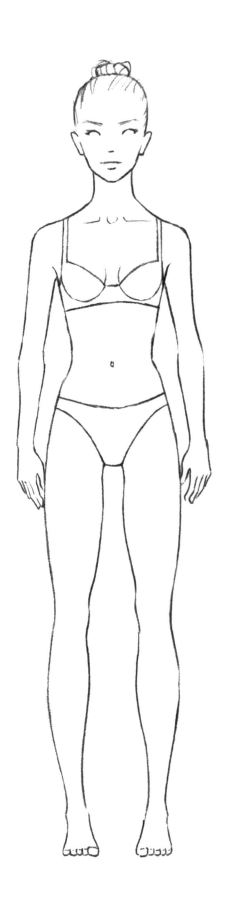

STEP 7

Using tracing or layout paper, trace the finished figure, or croquis, as it's traditionally called in the fashion industry.

Eliminate all of the drafting lines.

While tracing, feel free to make any small adjustments to improve the figure. This is the completed front draft of the female figure.

DRAFTING THE MALE, FRONT VIEW

The male figure is slightly taller than the female figure but the eight-head proportion remains the same. Therefore, the male head is slightly larger than the female head. This means that you can pair the male and female figures and they will appear believably matched.

MATERIALS

2B pencil
Pencil sharpener
Kneaded eraser
Ruler
Translucent layout paper or tracing paper

STEP 1

Draw a vertical line down the center of the paper. Make two marks at the top and the bottom of the figure, 8½" (21.6 cm) apart.

Leave margins at the top and the bottom to give the figure space.

Divide the figure's height into eight equal sections, each 1¹/₁₆" (2.7 cm) long.

Draw a horizontal line at the bottom mark for the floor.

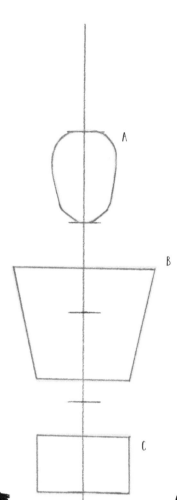

STEP 2

A In the top section, centered on the center line, draw an egg shape for the head. The bottom is angled for the jawline.

B Draw a trapezoid for the shoulders and rib cage. The top edge of the shape is halfway through the second section from the top. The top is wider than the bottom.

C In the fourth section from the top, draw a small rectangle for the hips. Make sure it's not as wide as the upper body.

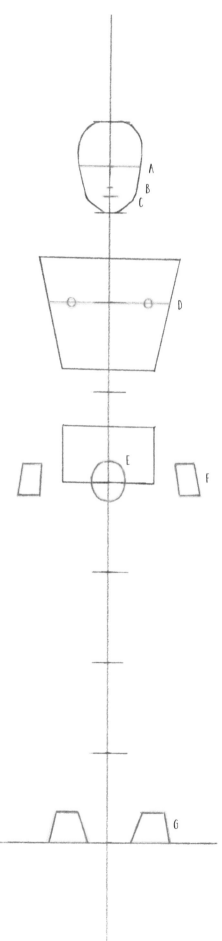

STEP 3

A Draw a horizontal line halfway between the top of the head and the tip of the chin to guide the eyes.

B Mark the tip of the nose halfway between the eye line and the chin.

C Mark the opening of the mouth halfway between the nose and the chin.

D At the third mark from the top, draw a horizontal line. Equidistant from the center line, draw two tiny circles for the nipples.

E Centered on the center mark and the center line, draw a small circle for the male figure's package.

F On either side of the hips at the center mark level, draw two small rectangles for the backs of the hands.

G On the bottom line, under the hips, draw two trapezoids for the fronts of the feet. Make sure the top is narrower than the bottom.

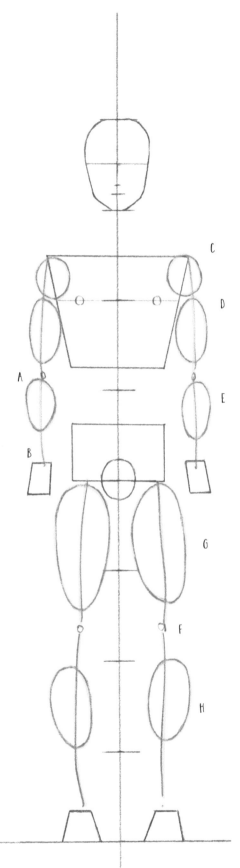

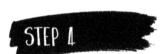

STEP 4

A Between the shoulders and the wrists, draw marks for the elbows. Make sure the upper and lower arms are equal.

B Connect the shoulders to the elbows, and the elbows to the wrists.

C At the shoulders, draw small circles for shoulder muscles.

D Along the upper arms, draw ovals for the biceps.

E Along the lower arms, closer to the elbow, draw ovals for the forearm muscles.

F Mark the knees halfway between the hips and the ankles.

G Connect the hips to the knees. Along these lines, draw large ovals for the thighs.

H Connect the knees to the ankles. Along these lines, draw smaller ovals near the knees for the calves.

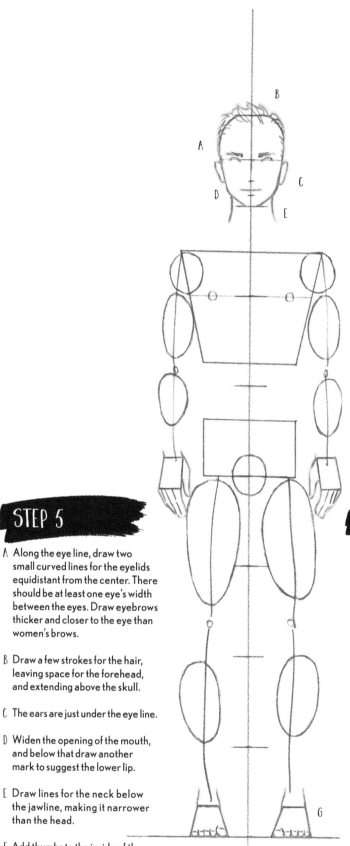

STEP 5

A Along the eye line, draw two small curved lines for the eyelids equidistant from the center. There should be at least one eye's width between the eyes. Draw eyebrows thicker and closer to the eye than women's brows.

B Draw a few strokes for the hair, leaving space for the forehead, and extending above the skull.

C The ears are just under the eye line.

D Widen the opening of the mouth, and below that draw another mark to suggest the lower lip.

E Draw lines for the neck below the jawline, making it narrower than the head.

F Add thumbs to the inside of the hands. Extend the fingers below the hand, about the same length as the backs of the hands.

G Draw five toes on each foot, with the largest toes on the inside.

STEP 6

Using the lines and shapes as a guide, draw the outline of the body. Use shorter, straighter lines to give the body a more angular, masculine quality.

Make the limbs narrower at the elbows, wrists, knees, and ankles.

Oh, and I almost forgot. Draw a tiny circle at the fourth mark from the top for the belly button!

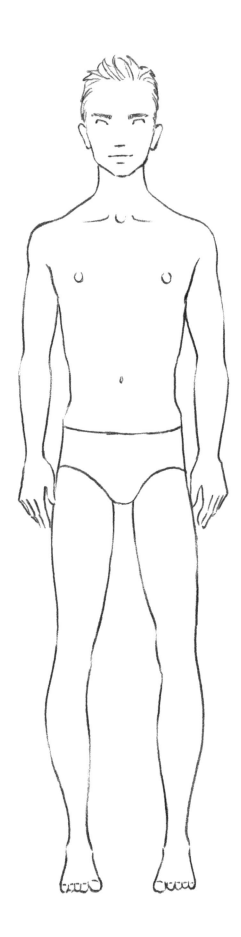

STEP 7

Using tracing or layout paper, trace the outlines and details of your figure, eliminating all the drafting lines and shapes.

This figure can be used as a guide for your future illustrations to help you check your proportions or as a template to do technical illustrations of garment designs.

DRAFTING THE FEMALE, SIDE VIEW

The side view of the figure, since it isn't symmetrical, will be the first introduction to the gesture line. A gesture line is an abstract line that establishes the attitude of the figure.

MATERIALS

2B pencil
Ruler
Translucent layout paper *or* tracing paper
Pencil sharpener
Kneaded eraser

STEP 1

Use the ruler to draw a vertical line through the center of your paper.

Draw two marks at the top and bottom for the height of the figure, 8" (20 cm) apart. Leave margins at the top and the bottom of the page.

Divide and mark the height into eight equal 1" (2.5 cm) sections.

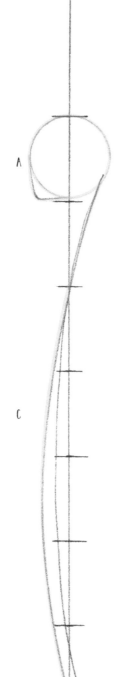

STEP 2

A In the top section, draw a circle shape for the head. Draw a corner on the lower left of the circle for the chin.

B In the bottom section, draw a triangular foot shape directly under the head. The foot is as long as the head is high, 1" (2.5 cm).

C Connect the head to the foot with a few quick, sweeping strokes. With a natural, relaxed posture, the center of the body sways forward slightly. This abstract line is a rough guide to give the figure a graceful gesture.

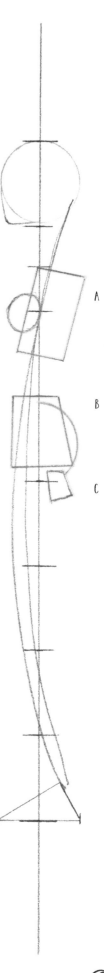

STEP 3

A Along the gesture line at the third mark from the top, draw a rectangle for the ribs and shoulders. Make sure the top of the shape is in the center of the second section from the top. Also on the third mark, draw an oval for the side of the breast.

B Draw a trapezoid for the hips just above the center mark. Draw a curve at the back of the hips for the butt.

C At crotch level, below the shoulder, draw a small rectangle for the back of the hand.

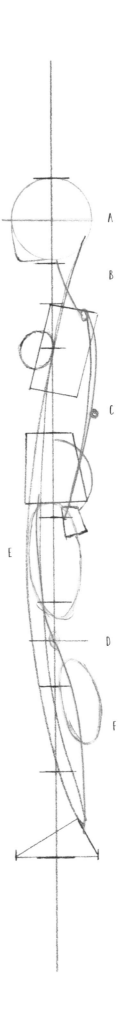

STEP 4

A Draw a horizontal line halfway through the head. This line will guide the eye placement in the next step.

B Connect the head to the shoulders. The neck leans toward the front.

C Draw a mark at the shoulder, and mark the elbow halfway between the shoulder and the wrist. Connect the shoulder, elbow, and wrist for the arm.

D Mark the knee halfway between the ankle and the hip, in the third section from the bottom.

E Connect the hip to the knee. The thighs gently curve toward the front. Draw a large oval along this line for the thighs.

F Connect the knee to the ankle. The calf curves toward the back. Draw another, smaller oval on the leg just under the knee for the muscles.

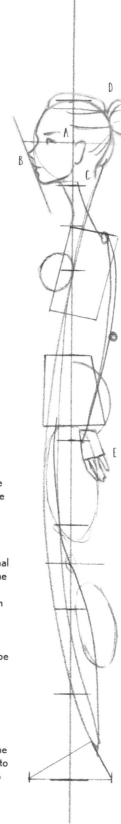

STEP 5

A Draw the eye on the eye line, toward the front of the head. From the side, eyes are flat at the front. Add an eyebrow above.

B This figure has Northern European, hyper-feminine facial features, with a pointed nose and small chin, so a diagonal line guides the profile. Mark the tip of the nose halfway between the eyes and the chin, and mark the opening of the mouth halfway between the nose and the chin.

C The ear sits below the eye line and behind the center line. Connect the lobe of the ear to the chin for the jawline.

D Draw the hair outside of the skull to show volume.

E Add fingers to the hand shape. The longest fingers are the same length as the palm. The hands should be long enough to cover the face. From the side, the thumb is hidden behind the palm.

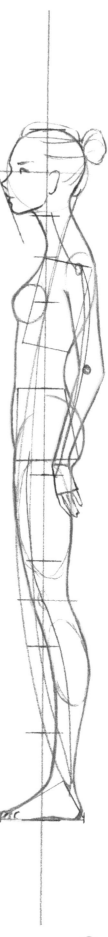

STEP 6

To flesh out the figure, draw the outline around the framework. For a feminine figure, use soft curves.

Draw limbs as if they are transparent to make sure the lines of the body look natural underneath.

If any part of the figure looks off, double check proportions. The torso and head combined are the same height as the legs. Upper arms are equal to lower arms, and thighs to calves. The feet, knees, body, and head are stacked on the center line to create a sense of balance.

If something looks wrong, keep drawing the lines until they look right to you. This sense is unique to every artist and is the basis of personal style.

This draft is a proportionally sound structure for your finished figure. Don't worry if it isn't neat. As long as you're satisfied with the outlines of the figure, it is successful.

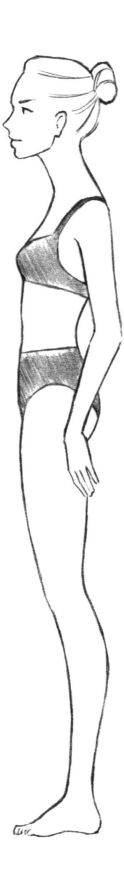

STEP 7

Trace over the figure's outline on
a sheet of layout or tracing paper,
omitting all of the drafting lines and the
framework of the figure.

Remember not to draw contours that
are hidden, like the curve of the hip
under the forearm.

DRAFTING THE MALE, SIDE VIEW

The side view, since it is not symmetrical, will have a gesture line. Once we're familiar with proportions we can start to approach more complex movements and poses.

MATERIALS

2B pencil
Pencil sharpener
Kneaded eraser
Ruler
Translucent layout paper or tracing paper

STEP 1

Draw a vertical line down the center of the page.

Mark the top and the bottom of the figure, 8½" (21.6 cm) apart, in the center of the page.

Divide the height of the figure into eight equal 1 1/16" (2.7 cm) sections.

At the bottom mark, extend a horizontal line for the floor.

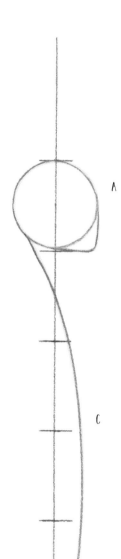

STEP 2

A In the top section, draw a circle for the side of the head. Add a corner to the lower right of the circle for the chin.

B Centered at the bottom, draw a triangle for the foot. The foot is one head (1¹/₁₆" [2.7 cm]) long.

C Shake out your arm and move back from your paper to draw the gesture line. Starting at the back of the head, it curves forward past the center line at the hips and then goes back to the ankle.

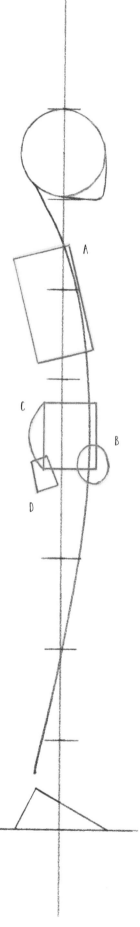

STEP 3

A Along the gesture line, slightly behind the head, draw a rectangle for the upper body. The top edge is halfway into the second section from the top.

B Along the gesture line, in the fourth section from the top, draw a rectangle for the hips. At the lower right corner of this rectangle, draw a small circle for the package.

C At the back of the hips, draw a curve for the butt.

D At the center mark level under the shoulders, draw a small rectangle for the back of the hand.

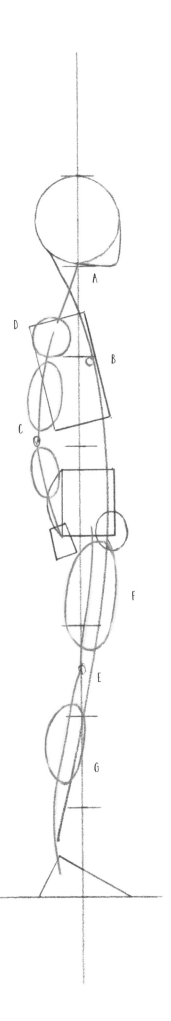

STEP 4

A Connect the head to the shoulders. The neck extends forward.

B Draw a tiny circle at the front of the torso, at the third mark from the top, for the nipple.

C Mark the elbow halfway between the shoulder and the wrist. Connect the shoulder to the elbow, and the elbow to the wrist.

D At the shoulder, draw a small circle for the shoulder muscles. Along the upper arm, draw an oval for the bicep. Along the lower arm closer to the elbow, draw another oval for the forearm muscles.

E Halfway between the hips and the ankle, draw a mark for the knee.

F Connect the hip to the knee. Along the thigh line, draw a large oval for the thigh muscles.

G Connect the knee to the ankle. Along the lower leg line, draw a smaller oval closer to the knee for the calf muscles.

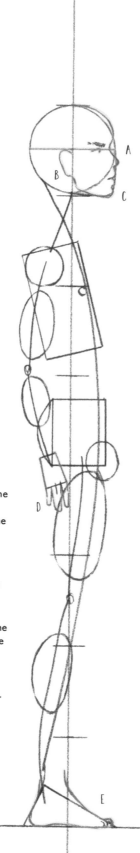

STEP 5

A Draw a horizontal line through the center of the head. The eye is on this line near the front of the face. From the side, the front of the eye is flat. Draw the eyebrow above.

B The ear sits to the left of the center line, under the eye line. Connect the lobe of the ear to the chin, defining the angle of the jaw below the ear.

C The tip of the nose is halfway between the eyes and the chin, and the opening of the mouth is halfway between the nose and the chin.

D Add four fingers to the back of the hand. The three middle fingers are the same length as the palm, and the little finger is shorter. From the side, the thumb is hidden behind the palm.

E Round the wedge shape of the foot, adding toes at the tip and an indent for the arch.

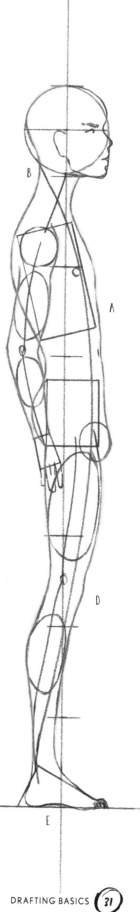

STEP 6

A Draw the outline of the body, guided by the framework.

B Make an indentation at the back of the head where the spine meets the skull.

C Add a point to the back of the elbow.

D Make a slight bump for the kneecap.

E This is the finished draft. Notice the head is directly over the foot, and the body is distributed on either side of the center line, so the figure stands sturdily.

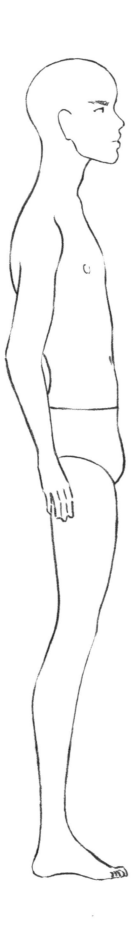

STEP 7

Using tracing or layout paper, trace the contours of the figure to create the finished croquis.

Be sure to eliminate any lines that are hidden, like the curve of the butt behind the forearm.

This concludes drafting basics! We've worked out the principles of proportion, and are ready to introduce gesture and movement.

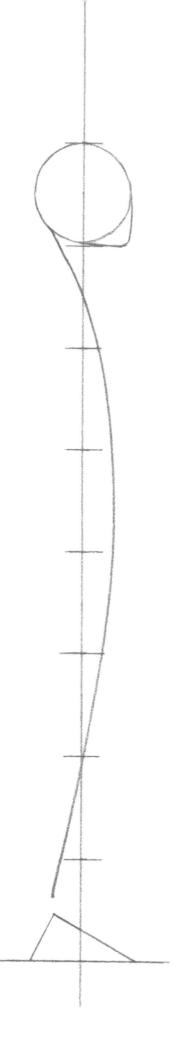

2

ILLUSTRATING RUNWAY FASHION

Twice a year, the fashion industry's insiders travel the circuit of fashion capitals to see what the world's most powerful designers propose for next season. Runway is fashion's imaginative theater, where reality's rules don't apply. Everything is exaggerated using styling, gimmicks, and of course, the arch, stylized walk of the models.

The walk is what we'll be focusing on in this chapter. Achieving a sense of hyper-realistic movement will give your drawings the same sense of drama and urgency we feel when we attend a fashion show. We'll draft models walking toward us in the classic pose recognizable from the infinite stream of photos from the photographers' pit, but we'll also challenge ourselves to draft side views. Although fashion show attendees are used to seeing the side view of a model's exit, it is very rarely successfully captured in photos. A confident rendering of a side view is something illustration is uniquely equipped to execute.

We'll be rendering our runway drafts using chalk pastels and pen and ink, giving us the chance to explore the concept of value, using highlights and shading to give our illustrations dimension and depth.

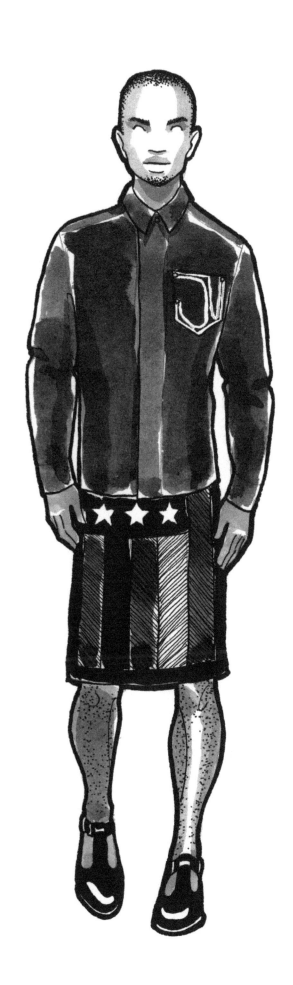

RUNWAY GESTURES

Runway flourishes aren't what they used to be. The modern form of catwalking is arched and understated. The shoulders are thrown back, and the head and hips are thrust ahead to optimize the female model's appearance in the photographs shot at the end of the runway. Male models tend to lean their shoulders forward for the same reason. It's odd that runway modeling has been warped by technology, so these unusual gestures are accepted as cool. Before the demands of standardized runway photography, models had much more freedom to express themselves.

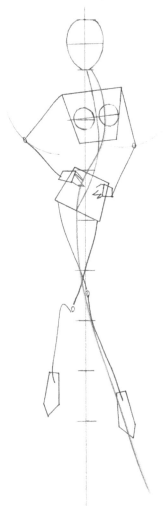

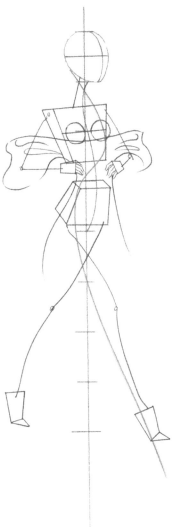

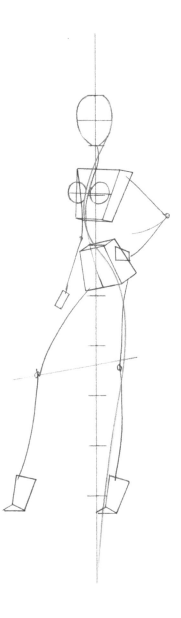

There are still a few models with famously fierce, zigzaggy walks, notably Naomi Campbell's sinuous strut and Karlie Kloss's angular stomp. The gesture is S- or Z-shaped.

You don't often see models "working" a garment anymore, but it's a treat to watch it being done well. A classic move is shrugging off a fur wrap or jacket to reveal the garment beneath.

At the end of the runway the model takes her "turn," perhaps with an elaborate flourish, although currently an understated pose like this one is more common.

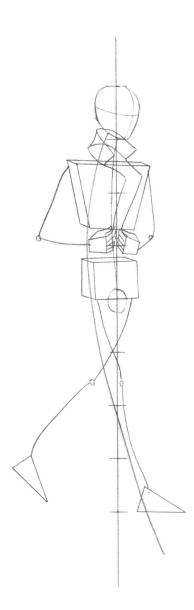

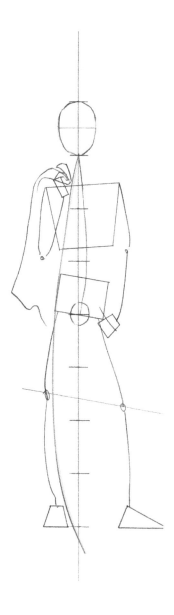

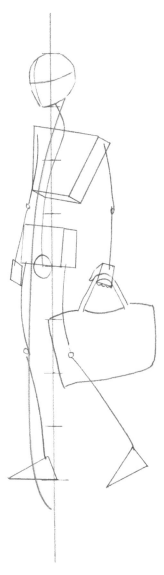

Male models walk very quickly, often leaning forward, so the gestures are swift strokes. It's common to see male models work their jackets.

It's currently considered a bit corny to toss a jacket over a shoulder but not unheard of for certain designers.

The only other common variation is when the model is holding something, such as a very large bag.

DRAFTING THE FEMALE RUNWAY FIGURE, FRONT VIEW

This century's defining fashion pose is striding toward the viewer. The front view of a model walking the runway is shot by countless cameras, countless times, rendering the image both iconic and ubiquitous.

Photographers are trained to shoot the model when her front foot hits the ground. This is also the moment we will draw.

This draft requires a sense of movement, and a gentle foreshortening of the far leg. Loosen up: shake and stretch before you draw. Use swift, light strokes to capture the energy of a model walking in a show.

MATERIALS

2B pencil
Pencil sharpener
Kneaded eraser
Ruler
Translucent layout paper or tracing paper

STEP 1

A Draw a vertical line down the center of the page. Mark the top and bottom of an 8" (20 cm) figure along this line, leaving margins above and below. Divide the height into eight equal 1" (2.5 cm) sections.

B In the top section, draw an oval shape for the head, pointed at the bottom for the chin.

C Loosen up, shake out your arm, and stand back from your page to draw the gesture line. To achieve an honest gesture, it's helpful to watch fashion show videos. Observe how a model's weight shifts from leg to leg, and how her shoulders balance that movement. The gesture line will go through the neck, the body, and down the front leg as the model steps toward you. Often it is a simple swipe, as it is here. Once you've got a feel for it, draw a line or three to get the movement down. Remember, this is not a representational line, so it can't be wrong. If it feels right, it's right.

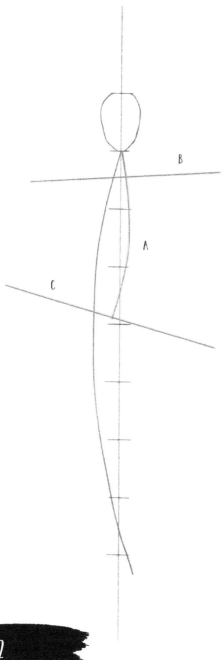

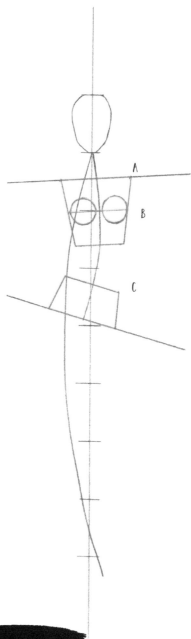

STEP 2

A Contraposto, or counterpose, is when the weight of a figure falls on one leg. In a walking movement, the entire weight is placed on the advancing leg. This causes the hip over the far leg to drop, tipping the hips at on opposite angle to the shoulders, which naturally compensate to balance the body. Since the gesture line flows through the front leg, the higher hip is along the gesture line, around the center mark. The spine will curve opposite to the gesture line, going from the head to the center mark.

B The shoulder level is halfway between the second and third marks from the top. Perpendicular to the spine at the shoulder level, draw a line for the shoulders.

C Perpendicular to the bottom of the spine, draw a line for the angle of the hips. Notice how the hips and shoulders go in opposite directions.

STEP 3

A Draw the upper body with the shoulder line at the top. An equal amount of the rib cage and shoulders is on either side of the spine. The shape is wider at the shoulders than at the waist.

B At the third mark from the top, parallel with the shoulder line, draw a line to guide the breasts. Along the line, draw two small circles. They are equidistant on either side of the spine.

C Draw a trapezoid for the shape of the hips. The hips are symmetrical and the spine goes through the center. The shape is narrower at the top.

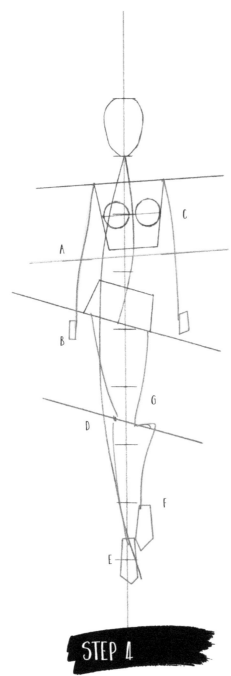

STEP 4

A Draw a line parallel with the shoulders, at the waist. This is where the elbows will fall.

B The wrists are also parallel with the shoulders, around the center mark. Draw small rectangles for the hands below the shoulders.

C Connect the shoulders to the wrists. Check that the upper arms are the same length as the lower arms.

D Draw a line parallel to the hips to guide the placement of the knees halfway between the hips and ankles.

E The front, weight-bearing foot's ankle falls about halfway through the bottom section. Since the figure is wearing heels, the foot extends below the lowest mark. Draw the weight-bearing foot exactly on the center line. The body needs to be stacked directly over it to appear balanced.

F The foot behind will be slightly higher, as it is being lifted as the front foot hits the ground.

G Connect the hips to the knees and the knees to the ankles. The line between the lower knee and the farther foot jogs, indicating the foreshortening of the far leg.

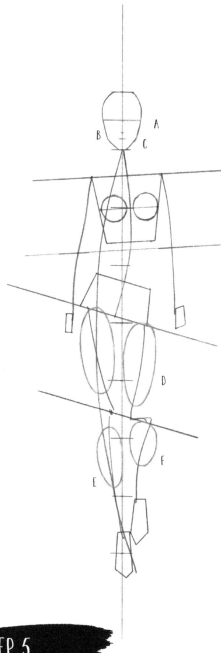

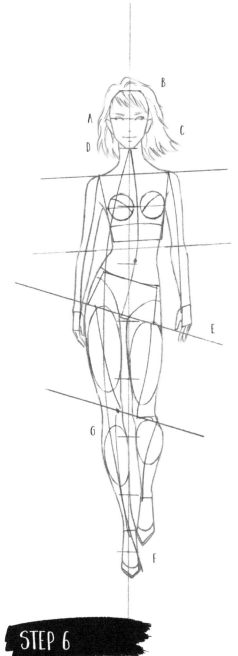

STEP 5

A Draw a horizontal line halfway through the head. This is the eye line.

B Halfway between the eye line and the chin, mark the nose.

C Mark the mouth halfway between the nose and the chin.

D Along the upper legs, draw two large ovals for the thighs.

E Along the lower leg line on the front leg, closer to the knee, draw a small oval for the calf.

F On the far leg, draw a shorter oval below the knee, because the lower leg is angled away.

STEP 6

A Draw eyes equidistant from the center, with one eye's width between. Add eyebrows above.

B Extend the hair above the top of the head and to the sides for fullness.

C The tops of the ears are level with the eye line.

D Extend the opening of the mouth, and mark below to suggest the lower lip.

E Add the thumbs to the inside edge of the hand shapes. Extend the fingers below. On the side view of the hands, the pointer finger is most visible. The long fingers are the same length as the main part of the hand.

F Refine the shape of the shoes to indicate pointed pumps. The points appear shorter from the front and longer on the top.

G Draw the outline of the figure guided by the framework. Since the far lower leg is angled away, it appears shorter.

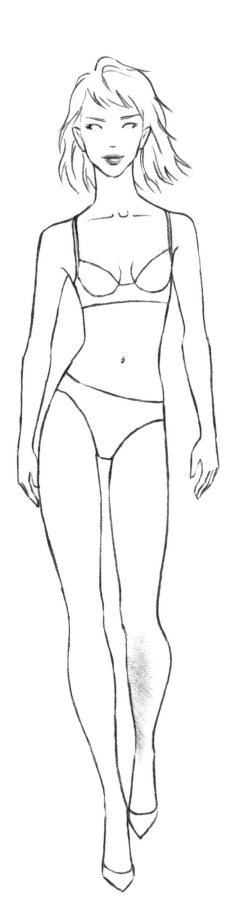

STEP 7

Using layout or tracing paper, trace the outlines of the figure, eliminating the drafting lines. I've added shading to the mouth, for lipstick, and to the far leg to make its receding position more obvious.

This croquis can be used for designing clothing, to give a sense of how that design might appear in a fashion show.

DRAFTING THE FEMALE RUNWAY FIGURE, SIDE VIEW

When seated at a fashion show, you get to see the full dynamism of a forward stride from the side. I've chosen to illustrate the point when both feet are touching the ground. This moment especially suits outfits like this one by Gareth Pugh, with a filmy cape trailing behind.

MATERIALS

2B pencil
Pencil sharpener
Kneaded eraser
Ruler
Translucent layout paper or tracing paper

STEP 1

A In the center of the page, draw a vertical line. Mark the top and the bottom of the figure 8" (20 cm) apart. Divide the height into eight 1" (2.5 cm) sections.

B In the top section, draw a circle for the side of the head. Draw a corner on the lower left of the circle for the chin.

C When runway models walk, they thrust their shoulders back and their hips forward, which is why the gesture line swings back below the head and forward at the hips.

D Since the figure is wearing platform heels, draw a horizontal line ½" (1.3 cm) below the bottom mark to represent the runway.

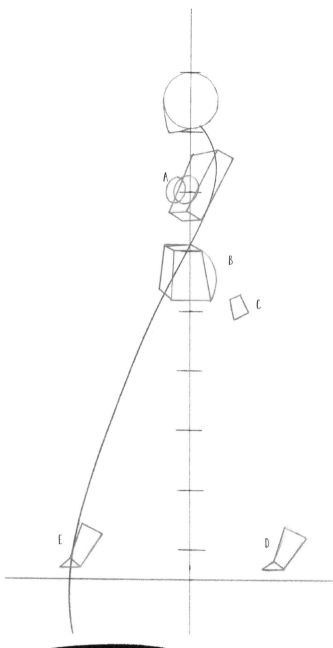

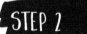

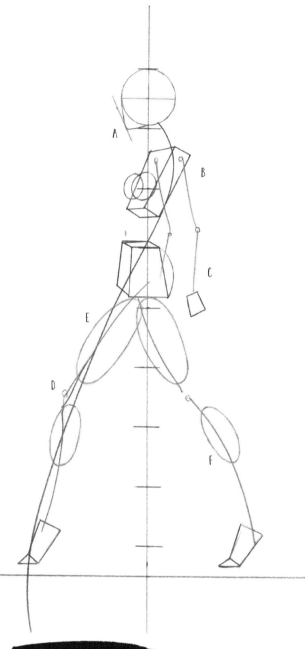

STEP 2

A The upper body looks like a box angled at the side, along the
 gesture line. The shoulders are toward the back. At the third
 mark from the top, draw two ovals on the front for the breasts.

B The figure is wearing heels, so the hips are angled back, making
 them parallel with the runway. Draw a curve at the back of the
 hips for the butt.

C Below the back shoulder, at crotch level, draw a small trapezoid
 for the back of the hand.

D Along the red carpet, draw two bent triangles to represent the
 feet in heels. The heel is level with the bottom mark. Leave a ¼"
 (6 mm) space under each toe for the platforms.

E The front foot is on the gesture line, equidistant from the center
 to the back foot.

STEP 3

A Draw a horizontal line halfway through the head. Draw a
 diagonal line from the chin to guide the profile.

B At the top corners of the upper body, mark the shoulders.
 Halfway between the shoulders and wrists, mark the elbows.

C Connect the shoulders to the elbows and the elbows to the
 wrists, except for the far hand behind the body.

D Mark the knees halfway between the hips and ankles, skewed
 forward because the legs are slightly bent.

E Using strokes that curve toward the front, connect the hips to
 the knees. Along these lines, draw large ovals for the thighs.

F Using strokes that curve toward the back, connect the knees to
 the ankles. Along these lines, closer to the knees, draw smaller
 ovals for the calves.

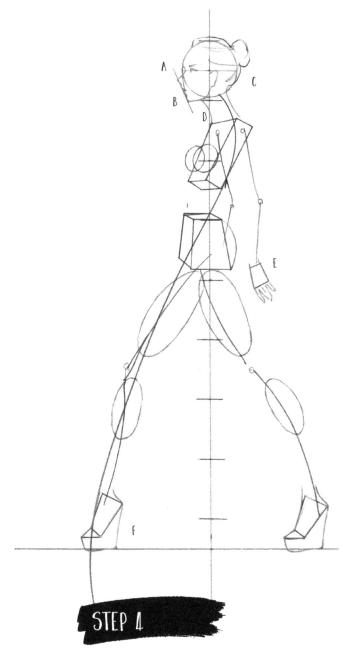

![STEP 4]

A On the horizontal line, draw the eye from the side, near the front of the head. Draw the eyebrow above.

B Draw the facial profile using the diagonal guideline. The nose tip is halfway between the eye and the chin, and the opening of the mouth is halfway between the tip of the nose and the chin.

C Indent where the spine connects to the head. Add hair, drawn outside the contour of the skull.

D The top of the ear is along the eye line, just behind the center line. Connect the earlobe to the chin. Extend the outlines of the neck toward the back of the figure.

E Add fingers to the hand. The length of the longest finger is equal to the length of the back of the hand. From the side, the thumb is hidden behind the palm.

F Add the platform shoes, rounding the triangles for the curved outlines of the foot.

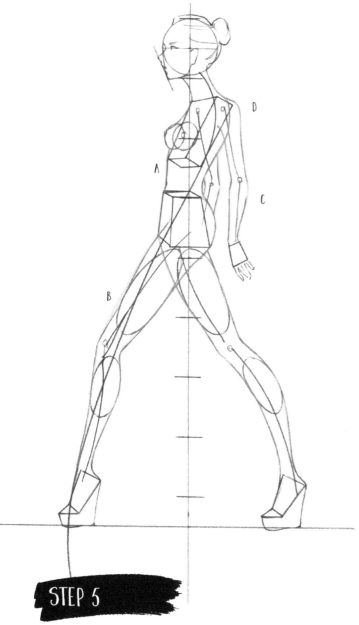

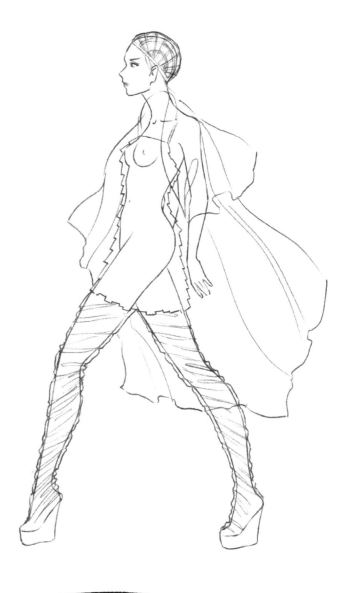

STEP 5

A Outline the figure, guided by the framework. Use gentle curves with an angular quality.

B Make sure the thighs and calves are visually equal in length and the upper and lower arms match, too.

C Remember to draw the elbow of the far arm, just visible behind the small of the back.

D Draw the curve of the upper back through the shoulder, so it appears believably connected to the neck.

STEP 6

Trace the figure from the draft onto a piece of layout or tracing paper.

Eliminate any lines that aren't visible through the body, including the front of the far thigh and the curve of the upper back.

Over the figure, draw the outfit, leaving space between the figure and the garments.

Use a jagged line to outline the dress, which is made of square paillettes, and a bumpy outline for the tall boots, which are wrapped and folded around the legs.

Connect the drape of the cape around the shoulders through the figure, to make sure it flows naturally.

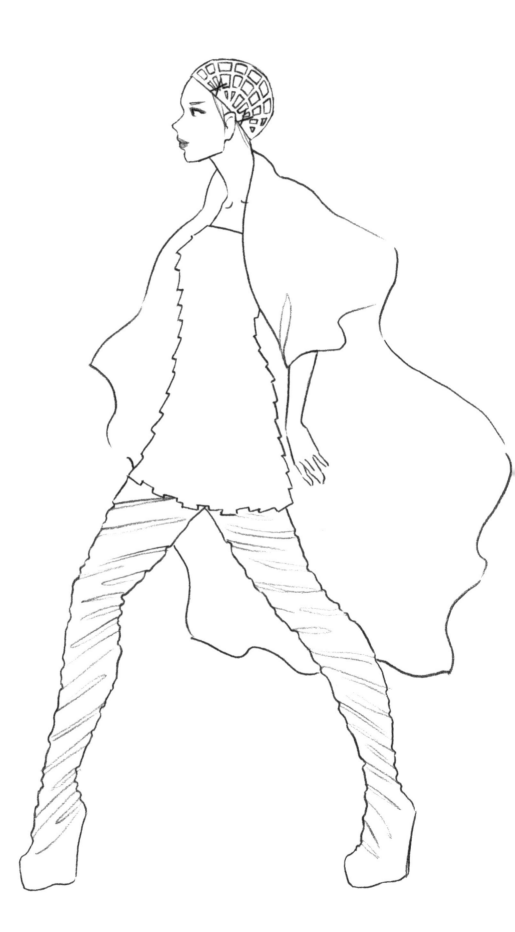

STEP 7

Trace over the draft from the last step, eliminating any lines of the figure obscured by clothing.

This is the draft of the drawing for the chalk pastel tutorial.

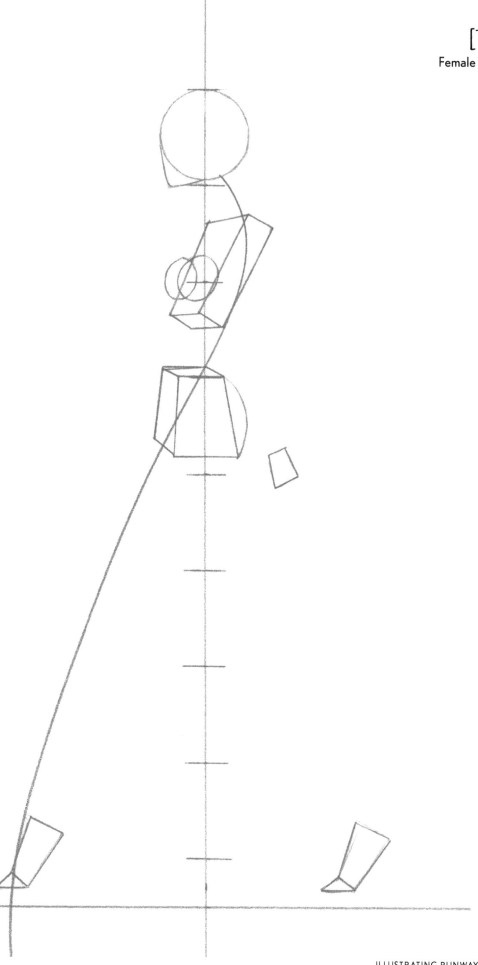

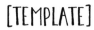

RENDERING IN CHALK PASTELS

Chalk pastels offer the opportunity to create softly blended shades and tones with a unique, powdery texture. When used on colored paper, light and dark chalk pastels create highlights and shadows to give a subject dimension.

This is a loose and expressive medium well suited to larger drawings and finger smudging. Since the tutorials are on a smaller scale, we will use a chalk pencil and a charcoal pencil to add definition, and a sharpened smudge stick for precise smudging on the facial features.

MATERIALS

9" x 12" (23 x 30.5 cm) colored paper
HB pencil
Pencil sharpener
Light box
2B pencil
Chalk pencil
Soft chalk pastels (white, peachy pink, pale yellow, brown)
Smudge stick
Wet wipes
Paper towel
Kneaded eraser
Charcoal pencil
Fixative spray

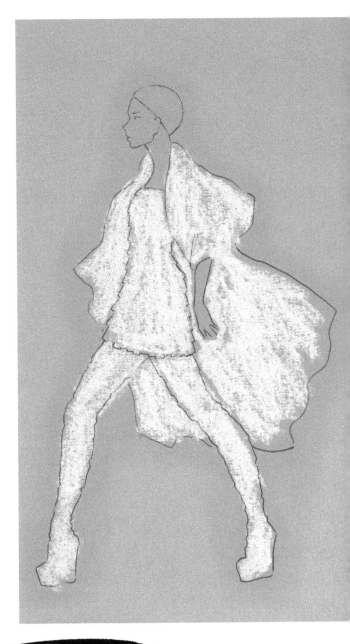

STEP 1

- Paper intended for chalk pastels often has a rough texture. For fashion illustration, a smoother finish works better. I've selected a skin-toned piece of paper.

- Using a pencil and a light box, trace the drawing. Trace lightly, eliminating smaller details. You need just enough information to establish the contours of your figure.

- The outfit is white, so use a white chalk pastel to roughly fill in the cape, the dress, and the tall boots. Don't worry about being neat. The imprecision of chalk pastels is their charm.

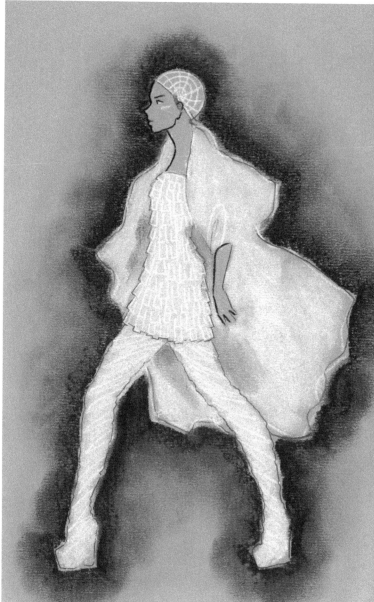

STEP 2

- Using your finger or a piece of tissue, smudge the white to make it smoother. If you are using your fingers, have wet wipes on hand to clean up. It's also useful to have a piece of paper towel to put under your palm so you don't inadvertently smudge any parts of the composition you want to leave alone.

- Use a pink chalk pastel to rouge the lips, cheeks, and eyes. Using a chalk pencil, draw in the whites of the eyes and the details of the headpiece, highlight the cheekbones and lower lip, and emphasize the folds and details of the outfit. The leggings are cream colored, so use a pale yellow pastel for the folds.

- Using a sharpened smudge stick, soften the pink details on the face so they look naturally blended.

- If you need to fix small mistakes, use a tiny piece of kneaded eraser and dab it on the drawing to lift any stray spots or smudges.

STEP 3

- Add definition to the face and arm, using a very sharp charcoal pencil. Draw the contour of the profile and the front side of the arms and fingers only, to keep it light. Use a piece of paper under your palm to avoid smudging the drawing.

- Using a dark brown chalk pastel, darken the contour around the outline of the figure. Be careful not to get any dark brown on the figure.

- Smudge the dark outline using your fingers in small circular motions. Switch fingers occasionally to keep the outer edge soft, but don't clean off your fingers yet. Use your dirty fingers to add subtler shadows to the figure, between the legs, and between the arm and the body.

- Once you're pleased with your work, you can preserve it with a fixative spray. Spray outdoors or in a well-ventilated area, and hold the can at least 6" (15.2 cm) away from your artwork to keep the application consistent.

DRAFTING THE MALE RUNWAY FIGURE, SIDE VIEW

The male model's runway walk is less mannered than the female one. In this draft, the model has erect posture, suitable for tailored clothing. For more casual styles, the shoulders and hips would slouch forward and the spine would be more rounded.

MATERIALS

2B pencil
Pencil sharpener
Kneaded eraser
Ruler
Translucent layout paper or tracing paper

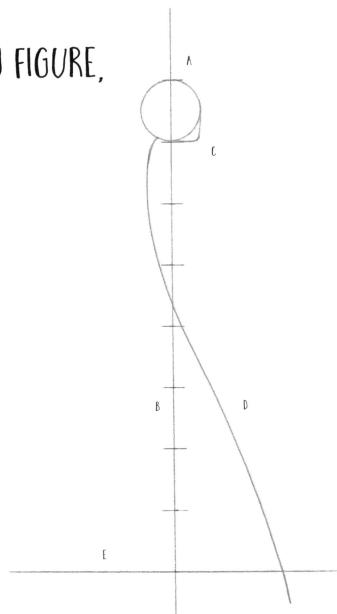

STEP 1

A Using a ruler, draw a vertical line down the center of the page. Along the line, draw two marks 8½" (21.6 cm) apart for the height. Leave space at the top and the bottom.

B Divide the height of the figure into eight equal 1¹/₁₆" (2.7 cm) sections.

C In the top section, draw a circle for the skull. Draw a corner on the lower right side of the circle for the jaw.

D The gesture line will start at the neck, swing back at the shoulders, and then swing forward to the hips, crossing around the center mark and moving forward with the front leg. Keep in mind the gesture line is not a literal line representing any part of the body, but an abstract line evoking the attitude.

E Draw a horizontal line at the bottom mark for the runway.

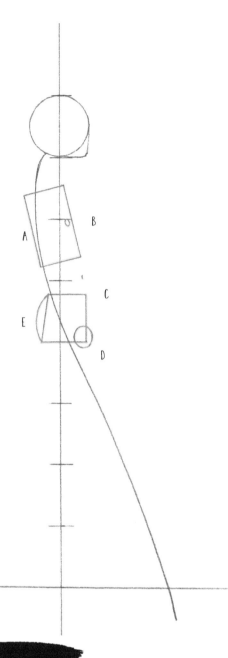

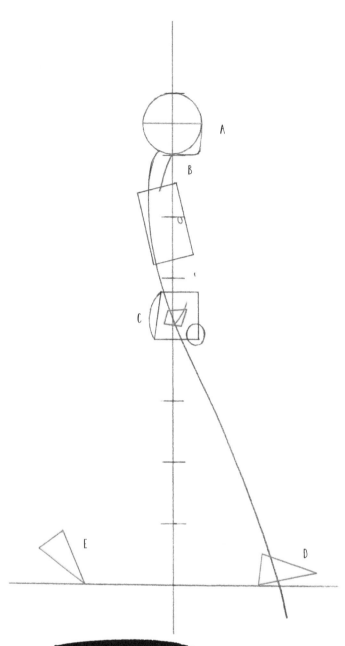

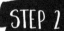
STEP 2

A Along the gesture line, draw a rectangle for the upper body. The top of this shape is halfway through the second section. Make sure the shape is positioned behind the head.

B The nipple is at the front of this shape, at the third mark from the top.

C In the fourth section from the top, draw a trapezoid for the side of the hips.

D On the lower right-hand corner, draw a small circle for the package.

E On the left side of the hips, draw a curve for the butt.

STEP 3

A Draw a horizontal line through the head to guide the eyes.

B Connect the head to the shoulders for the neck. Notice that the head goes forward.

C Over the hip, draw a short curve for a western pocket. Draw a small trapezoid over the pocket for the back of the hand.

D Along the runway, draw two triangles for the feet. The feet are the same length as the head, 1¹/₁₆" (2.7 cm).

E The back foot is lifting off of the toe. The front foot is hitting at the heel. Each foot is equidistant from the center line.

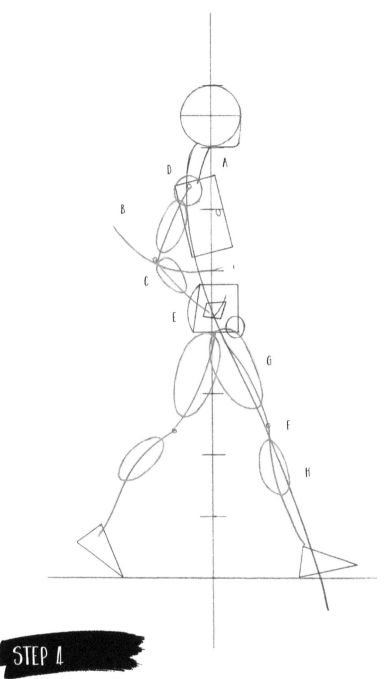

STEP 4

A Draw a mark behind the base of the neck for the shoulder.

B The upper arm's length is from the shoulder to the waist. Using that length, draw a curve using the shoulder as an axis. This curve will guide elbow placement.

C Since the length of the forearm is the same as the upper arm, that same length from the wrist will be where the elbow is along the curve.

D Connect the shoulder to the elbow. Draw a small circle around the shoulder. Draw an oval along the line of the upper arm for the bicep.

E Connect the elbow to the wrist. Draw a small oval along the line of the lower arm, closer to the elbow.

F Mark the knees halfway between the hips and the ankles.

G Connect the hips to the knees. Along these lines, draw large ovals for the thighs.

H Connect the knees to the ankles. Along these lines, close to the knees, draw ovals for the calves.

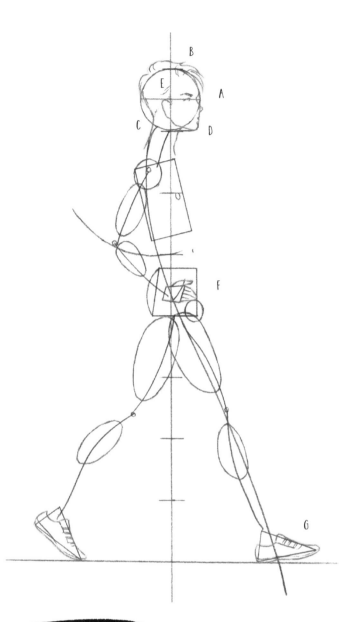

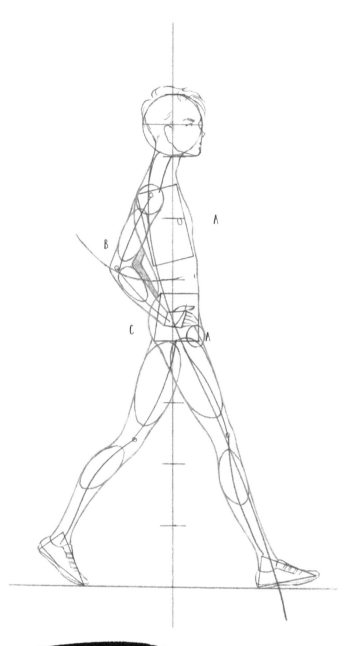

STEP 5

A Draw the eye along the eye line near the front of the head. From the side, the front of the eye is flat. Draw the eyebrow above.

B Add the model's hair, extended above the edge of the skull.

C Add the neck below the head, indenting where the spine meets the skull.

D The model for this drawing has Northern European features. Extend the forehead forward so it's flatter. Emphasize the indent below the brow and the point of the nose. The lips are narrow.

E The placement of the ear is under the eye line and behind the center line. Connect the ear to the chin for the jawline, defining the corner of the jaw below the ear.

F At the top edge of the hand draw the thumb. It will be visible outside of the pocket. Rendering fingers is optional because they are concealed.

G Over the feet, add shoes. Extend the toes, especially on the back shoe where it bends as it lifts off the ground.

STEP 6

A Using the framework as a guide, draw the outline of the body. Use shorter, straight strokes instead of soft curves, to give the body masculinity.

B Add a second arm just behind the visible arm. I've shaded it so it seems further away.

C Be sure to draw through the curve of the upper back and the curve of the butt behind the visible arm, so these parts look natural on the final draft.

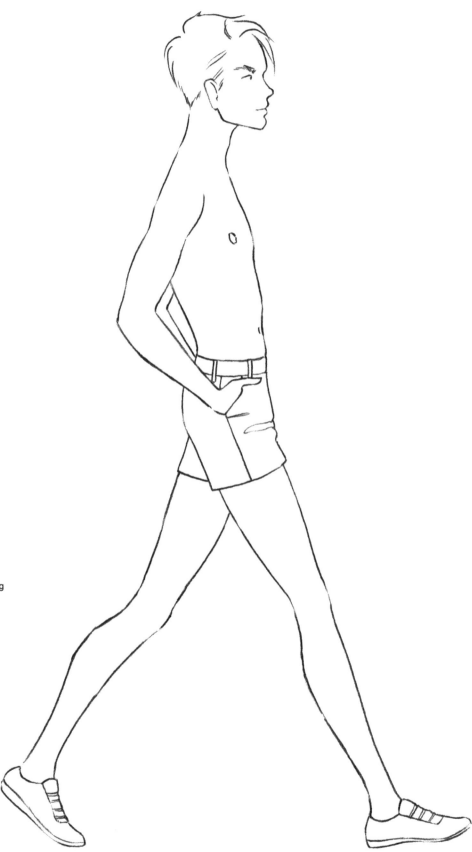

STEP 7

Trace the outline of the figure, adding the shorts.

Omit drawing all of the structural guidelines and any contours that are hidden by the arm, like the upper curve of the butt.

When drawing the shorts, be sure to hide the fingers inside the pocket. Add a crease where the front leg bends forward.

DRAFTING THE MALE RUNWAY FIGURE, FRONT VIEW

When female models walk, they seem like they're on a tightrope, placing each foot directly in front of the other. A male model's runway stance is wider, with the feet and legs further apart.

The "street cast" inspiration for this draft tutorial has African features and a muscular build. There is a loose, strong, proud way that the model carries himself, so summon those qualities in yourself when you draw to give your work the same energy. One way to do that is to listen to music.

MATERIALS

2B pencil
Pencil sharpener
Kneaded eraser
Ruler
Translucent layout paper or tracing paper

STEP 1

A Draw a vertical line down the center of the page. Mark the height of the figure, 8¹/₂" (21.6 cm). Leave space at the top and bottom.

B Divide the height into eight equal 1¹/₁₆" (2.7 cm) sections.

C In the top section, draw an egg shape for the head. Place the pointed end at the bottom, and square it off to suggest the jawline.

D From the head to the bottom of the figure, draw a sweeping gesture line to establish the movement of the figure. That line will go through the body to the leg that is stepping forward. Since it's a masculine figure, the gesture line is only subtly curved. Remember, this line is abstract, so it doesn't need to be exact.

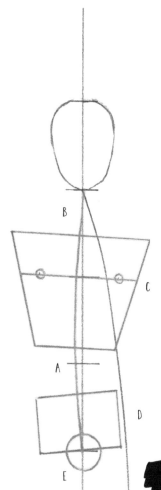

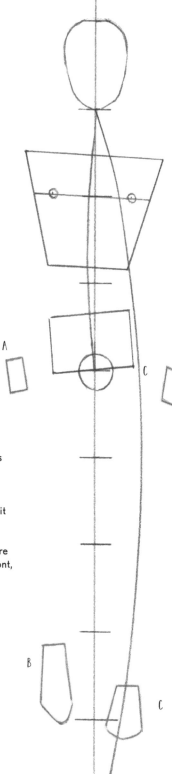

STEP 2

A Draw the spine from the bottom of the head to the center mark. The spine bends opposite to the gesture line. Because the front leg is holding the weight of the figure, that hip is higher. To balance the weight, the upper body bends toward the high hip, making the spine curve.

B Perpendicular to the spine, draw a trapezoid for the rib cage and shoulders. The top of the shape is wider. The spine goes through the center of this shape.

C At the third mark from the top, draw a line parallel with the shoulders to guide the nipples. Mark them on the line equidistant from the spine.

D In the fourth section from the top, perpendicular to the spine, draw a rectangle for the hips. This rectangle is narrower than the upper body. The spine goes through the center of the hips.

E At the center mark, draw a circle for the model's package.

STEP 3

A The hands are at crotch level, parallel with the shoulders. Draw the hands farther out because the bicep muscles cause the arms to bend away from the body.

B The far foot is seen from the top, so it appears longer.

C Draw the landing foot along the gesture line. Since this foot is seen from the front, it appears shorter.

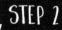

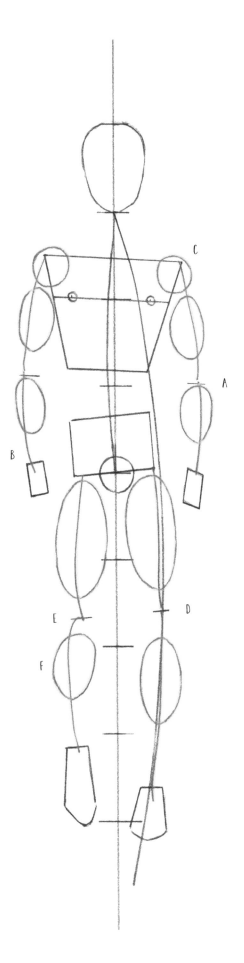

STEP 4

A Mark elbows level with the fourth mark from the top, parallel with the shoulders.

B Connect the shoulders to the wrists. Because of muscles, the arms bow out from the body.

C Draw circles around the shoulders to make them broad. Along the arms, draw four full ovals for muscles.

D Mark the knees parallel with the hips, halfway between the hips and ankles.

E Using quick strokes that bow out from the center, connect the hips to the knees and the knees to the ankles. Jog the far leg line to indicate foreshortening.

F Along the thighs, draw large ovals for muscles. Along the lower legs near the knees, draw smaller ovals for the calves. The oval on the far leg appears rounder because it is angled away.

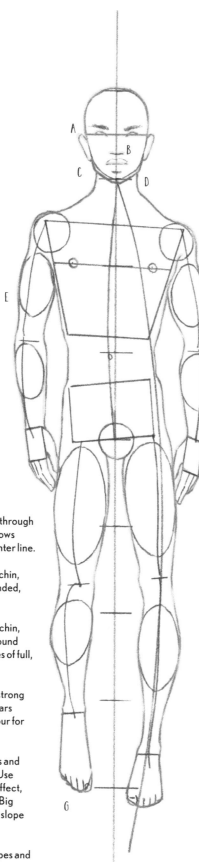

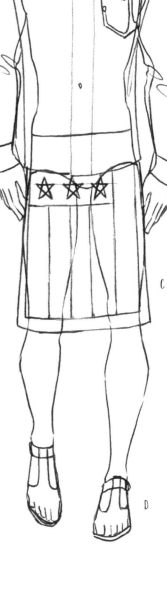

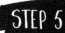

STEP 5

A Draw a horizontal eye line halfway through the head. Draw the eyes and eyebrows equidistant on either side of the center line.

B Halfway between the eyes and the chin, mark the nose, curving it like a rounded, flattened M shape.

C Halfway between the nose and the chin, draw the opening of the mouth. Around the mouth, lightly indicate the edges of full, round lips.

D African facial structure features a strong jaw that projects forward and appears larger. Draw a square, strong contour for the jaw just below the head shape.

E Guided by the framework of shapes and lines, draw the outline of the body. Use strong, short lines for a masculine effect, emphasizing the bulging muscles. Big muscles also shorten the neck and slope the shoulders.

F For the hands, add large thumb shapes and thick fingers. The fingers are as long as the backs of the hands, and the entire hand is large enough to cover the face.

G At the ends of the feet, divide the shape into five toes, with the big toes at the center.

STEP 6

A Using tracing or layout paper, trace the face, outlines, and details of the figure. Eliminate the drafting lines. On top of this, layer on the clothing.

B Curve the collar so it appears to go around the neck. Make sure that the clothing stands away from the body, as this outfit is made of sturdy denim fabric.

C The model wears a skirt. Make sure the hem of the skirt is level with the hips. Carefully draft the flag patchwork so the seams are perpendicular to the hem. Curve the hem slightly to wrap it around the body. When drafting the stars, a guideline keeps them even.

D The top edge of the shoes will appear to curve up on the far foot and down on the front foot.

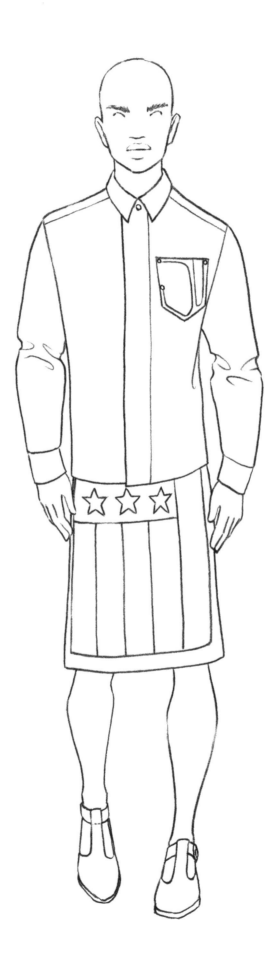

STEP 7

Using tracing or layout paper, trace the final version of the draft.

Be sure to eliminate all of the lines of the body that are obscured by clothing.

This draft will be the basis of the rendering in the ink tutorial.

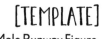

[TEMPLATE]
Male Runway Figure,
Front View

RENDERING IN INK

Using a nib pen and ink for fashion illustration recalls the wonderful work of Charles Dana Gibson from the early twentieth century, when the graphic quality of ink was favored for how well it reproduced on newsprint. Water-based ink can be used like watercolor, with more intense saturation. This tutorial uses three classic techniques: wash, hatching, and stippling.

MATERIALS

Light box
Pencil sharpener
HB pencil
Two sheets 140lb hot press watercolor paper
Liquid frisket
Nibs: flexible nib 33, bowl pointed nib 513EF, round tip nib B5
Nib pen handle
Tissues
Water-based ink in black and indigo
Water containers and water
Paint palette
Round sable paintbrush, size 4
Rubber cement pickup
Kneaded eraser

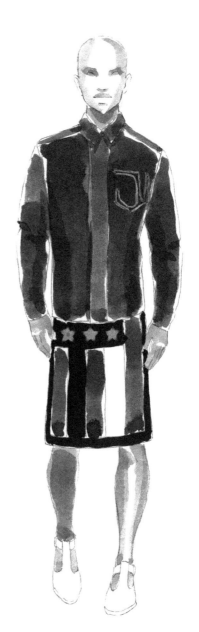

STEP 1: WASH

• Using a light box and an HB pencil, trace the artwork from the previous draft tutorial twice onto two sheets of hot-press watercolor paper. The second tracing is to "rehearse." If you mess up in ink, you have to start over, so a test page is useful.

• Shake the frisket, and then insert the flexible nib into the pen handle. Apply frisket to the eyes, the stars on the skirt, and the topstitching on the shirt pocket. Immediately clean the pen. Make sure the frisket is dry before you paint!

• For the skin tone, mix a bit of black ink and water on your palette with your brush and test it. If it's too dark, add more water. Practice the hands and legs first. Leave highlights unpainted. Reduce the strokes to a minimum, and make each continuous. Too many strokes look overworked.

• When you paint the face, do the neck first. Paint a stroke on either side of the head, narrowing under the eye to suggest cheekbones. Do small dabs under each eyebrow, under the nose, on the top lip, and under the lower lip.

• Wait for the first pass to dry, and using the same wash, add shading. Paint a shadow under the chin, on the far leg, two narrow strokes on either side of the front leg, and a dab on the front knee.

• Rinse your brush and dip it into the indigo ink. Using pure ink, paint the darkest areas of the skirt. Then dilute the indigo ink with water on the palette. Test until you like the midtone. Paint three midtone stripes on the skirt and the shirt.

• Wait for the shirt to dry, then use the same midtone for shading: under the arms, on the sides of the shirt, under the collar, and at the elbows for wrinkles. Rinse and dry your brush.

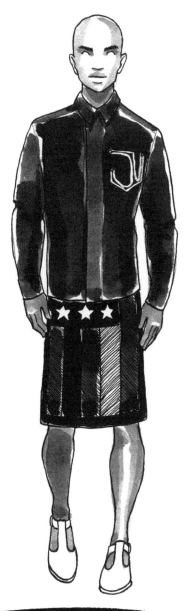

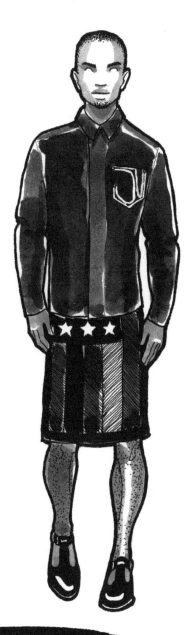

STEP 2: HATCHING

- Wait for the drawing to dry completely. Using the rubber cement pickup, carefully lift the frisket off.

- Insert the bowl pointed nib in the handle. Dip it into the black India ink. Now we will define the details and outlines of the figure. Don't render everything so it won't look over-worked.

- Be careful not to smudge wet lines. Work from top left to bottom right if you're right handed or from top right to bottom left if you're left handed, or rotate the paper. Use a scrap of paper under your hand if necessary. Once you're done, clean and wipe your nib.

- Using the same nib, dip your pen in the indigo ink. A series of closely spaced lines suggests shading and texture. This is called hatching.

- Hatching can use straight or curved lines, continuous or dotted lines, or even crossed lines, called crosshatching. We will use straight diagonal lines to suggest twill. Hatch the midtone panels on the skirt and the unpainted panel on the skirt. Then clean and wipe your nib.

STEP 3: STIPPLING

- Stippling is another technique to suggest shading or texture. It involves tapping the nib on the paper to create many tiny dots. Practice on the test sheet. Consistent dots take practice.

- Stipple the top of the head for the hair, the chin for a small goatee, and on the legs.

- Wash and wipe your nib, and replace it with the round tip nib. This nib makes a thick line. Outline the entire figure to make it pop. Fill in the shoes too, leaving highlights to suggest shiny patent leather. This is the finished illustration.

3

ILLUSTRATING STREET STYLE

The rise of street style as a distinct aesthetic influence within the fashion industry parallels the rise of digital photography and the Internet. Appropriately, many of the gestures associated with street style are influenced by technology. It's almost impossible to separate the street style aesthetic from the medium of photography, which makes adapting it to illustration a postmodern exercise.

Street style is no longer an outsider art—it has become synonymous with photographing the arrivals, departures, and hangers-on outside of fashion shows. This particular genre of street style has some very specific conventions of its own, which will inspire us in this chapter.

When creating the final illustrations, we'll explore the difference between tight and loose rendering. Tight rendering is when you color in your drawing from edge to edge, staying within the lines. It's precise and fastidious, and we'll try it in colored pencil. Loose rendering is the opposite. It's sloppy, leaves lots of white space, and isn't precious. We'll get loose and messy using markers.

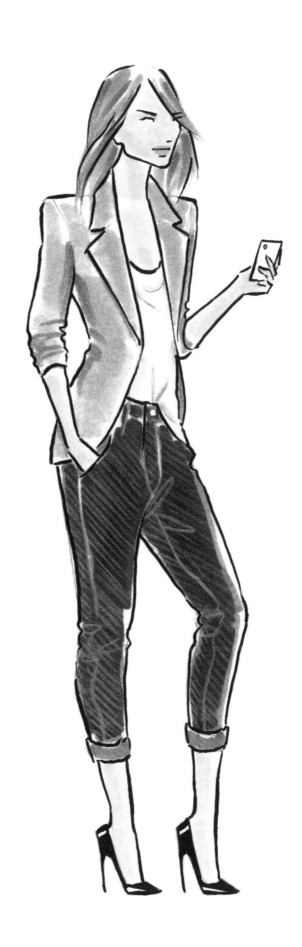

STREET STYLE GESTURES

Street style posing is either walking and "unposed," or standing and posed. Even when static, it's so understated it appears unposed. Gesture lines tend to be simple swipes, and there isn't much difference between the sexes. The way women dress on the street is more masculine than what is often seen on the runway or red carpet.

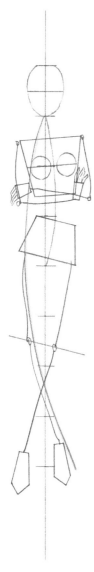

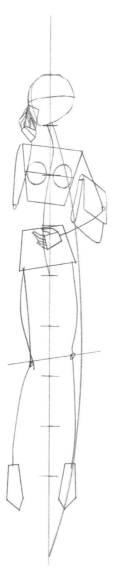

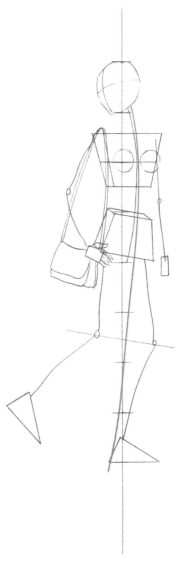

Arms and legs both crossed is cool body language. This pose is often seen with a jacket draped over the shoulders. Notice the weight-bearing leg is behind and the free leg is in front.

The smartphone is the most ubiquitous street style accessory. The conceit is that the subject is too busy or important to pose. Handbags are important to the street style look, and so is the way they're held. Here a clutch is tucked under the arm.

Walking by is another "unpose." Here the subject is throwing the viewer a look over her shoulder. The shoulder strap could be hooked through the hand, either low or high. Flat shoes are common in street style looks.

Status is distinguished by the objects the figure holds: a device and a fashion show invitation.

Texting is also common, though it shortens the figure because the head is leaning over. Here you see a foreshortened face and head, and also the tops of the shoulders.

Before there were cell phones there was the original manual fixation: the cigarette. In the fashion world, cigarettes are still common but increasingly subjects conceal them, or use vaporizers. Vaporizers have a different gesture because of the weight of the device.

DRAFTING THE MALE STREET STYLE FIGURE

You will notice when you look through reference images that there is not a lot of variation in masculine street style poses. Straight-looking men tend to stand, well, straight. Sometimes their hands are in their pockets. The only nod toward pose is leaning against a pole or a wall, as this figure does.

MATERIALS

2B pencil
Pencil sharpener
Kneaded eraser
Ruler
Translucent layout paper or tracing paper

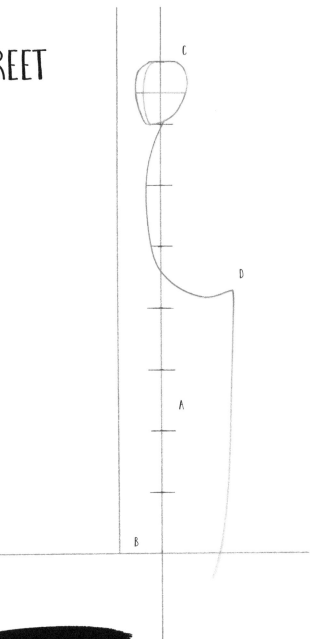

STEP 1

A Draw a line down the center of the page. Mark the top and the bottom of the figure, 8½" (21.6 cm) apart. Divide the height into eight equal 1 1/16" (2.7 cm) sections.

B Draw a flat line at the bottom mark for the street. Draw a vertical line for the figure to lean on, ¾" (1.9 cm) to the left of the center line.

C Draw an egg shape for the head, pointed on the lower left. The head is at a three-quarter view, so the center front line of the face wraps around the head. Draw a horizontal line halfway through the head to guide eye placement.

D The figure's weight is resting on both the wall and the opposite hip, so the gesture line traces the flow of that weight, swinging toward the wall and then away where the hip juts out. Remember, the gesture line is not representative of any body part; rather, it establishes attitude for the figure. Keep it simple and stylized.

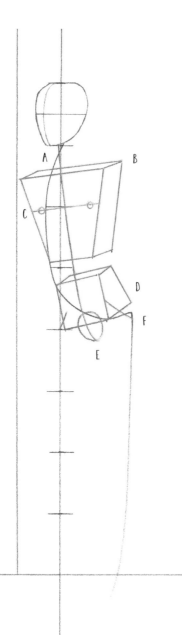

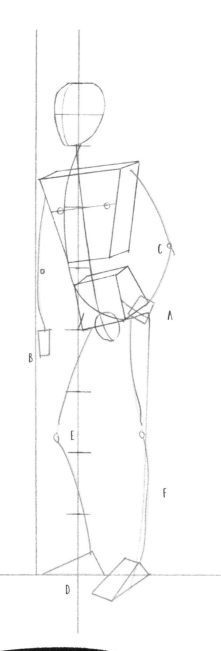

STEP 2

A Draw a line from the head to the crotch for the center front line of the body. For a masculine effect, this line is almost straight.

B Perpendicular and centered on the center front line, draw a trapezoid for the upper body. The shape is top-heavy. Since the figure is at a three-quarter view, extend the trapezoid to a three-dimensional box shape. Because the torso is leaning forward, the top of the box is visible.

C Draw a line at the third mark from the top, parallel with the shoulders. Draw nipples on this line equidistant from the center front.

D Perpendicular and centered on the center front line, draw a rectangle for the hips. Extend the shape to make a cube. Since the body is leaning forward, the top of the cube is visible.

E At the center line, level with the center mark, draw a small circle for the package.

F On either side of the hips, equidistant from the center front line, draw diagonal lines for pockets.

STEP 3

A Draw the back of the hand over the top of the pocket line on the higher hip.

B The other hand is hanging next to the wall, so draw a rectangle at the center mark.

C Mark the elbows at waist level. Connect the shoulders to the elbows to the wrists for the arms.

D Draw one foot from the side, directly under the center line. The foot is a 1$\frac{1}{16}$" (2.7 cm) triangle. Draw the other foot just under the high hip. It's tilted forward, like a wedge.

E Mark the knees halfway between the hips and the ankles. The knees are parallel to the hips.

F Connect the hips to the knees to the ankles.

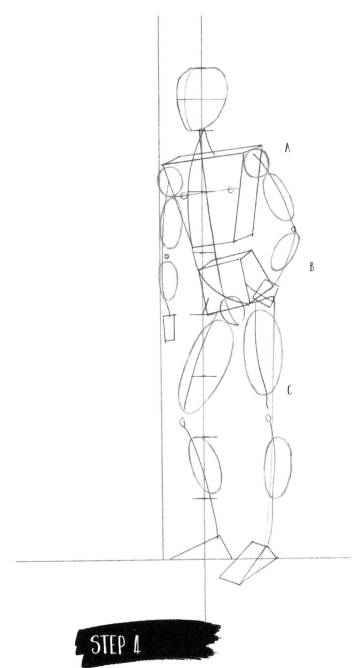

STEP 4

A Round shapes at the shoulders define a broad, masculine build.

B Ovals at the upper arm and lower arm give the limbs a strong shape.

C Large ovals between the hips and knees shape the thighs, and smaller ovals under the knees shape the calves.

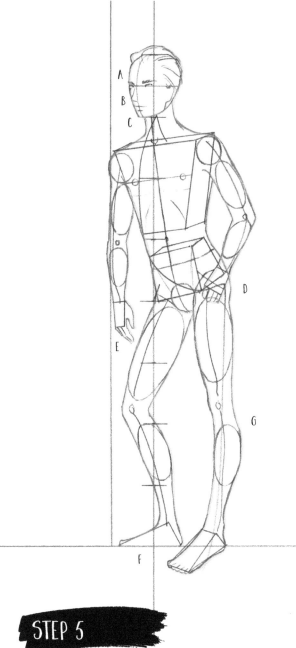

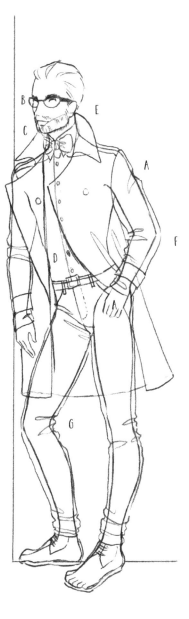

STEP 5

A The eyes are on the eye line. The eye behind the nose is partially obscured. The other eye appears close to the center front line.

B Extend the nose beyond the center front line since it protrudes from the face. The tip is halfway between the eye line and the chin.

C The opening of the mouth is halfway between the nose and the chin. Mark below the mouth to suggest the lower lip.

D Hook the thumb into the pocket. The fingers on that hand are bent, so the fingertips aren't visible.

E For the hanging hand, extend the thumb to the side toward the body. The hand is long enough to just cover the face.

F Add toe shapes to the feet.

G Draw the outline of the figure around the framework.

STEP 6

A Trace over the outline of the draft of the figure.

B The glasses start as a line above the eyes, connected to the top of the ear. The frames are partially hidden behind the nose.

C Add the beard using short lines in the direction of hair growth.

D When dressing the figure, make sure the bow tie, the buttons for the shirt, and the fly on the jeans follow the center front line.

E Extend the back of the collar through the head to make sure it lines up. Also do this for the hem of the jacket behind the legs.

F Wherever the jacket is compressed, such as inside the bent elbow, draw folds.

G On the jeans, draw folds where the leg bends at the hip and the knee, and at the cuffs.

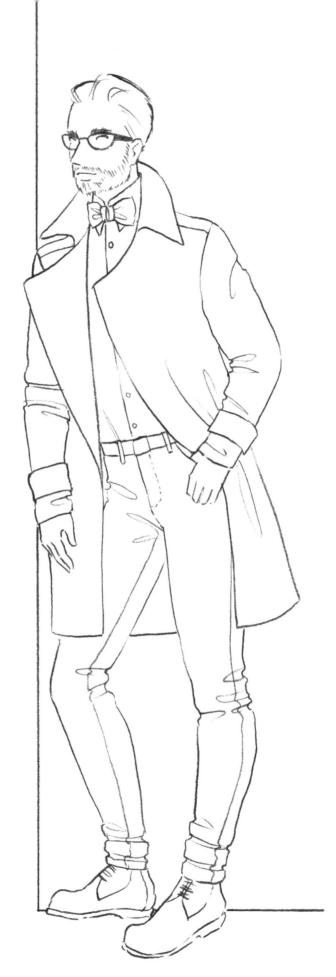

STEP 7

Trace over the dressed figure, eliminating the lines of the body under the clothes and any lines obscured by the figure, such as the collar behind the head.

Add seams to the jeans, wiggling them at the wrinkles.

RENDERING IN COLORED PENCILS

Colored pencils are a widely available art supply. You don't often see them used in commercial fashion illustration anymore, but they are still used by fashion designers. Get the finest ones you can afford; highly pigmented pencils are a pleasure to blend. This is a tight rendering, faithfully adhering to the lines of the draft.

MATERIALS

HB pencil
Mixed media paper
Colored pencils (I used Prismacolor Premier in the following colors):
Beige, Peach, Ginger Root, Eggshell, Orange, True Green, Light Cerulean Blue, Pink, Spanish Orange, Putty Beige, French Grey 20%, Indigo Blue, Black
Pencil sharpener
Ruler
Kneaded eraser

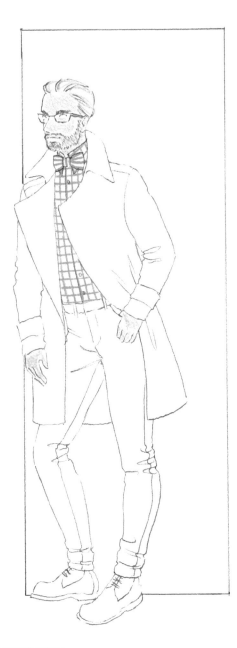

STEP 1

- Using a light box or equivalent, lightly trace the male street style draft onto mixed media paper. Select paper with a fine "tooth," a texture that gives the colored pencil something to grab on to, without being too rough.

- For the skin, I lightly applied two colors, Beige and Peach, to get the shade I wanted.

- For the hair, eyebrows, and beard, use a few short strokes following the direction of the hair. I used Ginger Root and Eggshell. Don't fully color in the hair, or it will look overworked.

- The bow tie and the shirt are patterned in stripes and checks. Using True Green, draw the vertical lines of the shirt's check pattern first, guided by the placket. Then draw the horizontal lines perpendicular to the placket.

- For the bow tie, make sure the Pink stripes are vertical at the knot and horizontal at the loops. Using the Spanish Orange pencil, fill in the stripes of the bow tie.

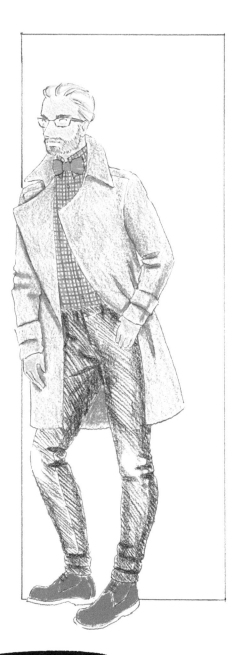

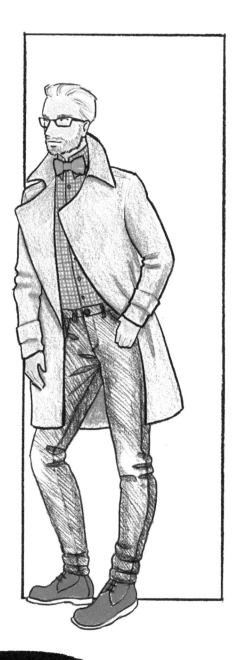

STEP 2

- On the shirt, add another grid of light Cerulean Blue to create the checked plaid. Use Light Cerulean Blue for the shoes, firmly pressing the pencil so the color fills in completely, creating a glossy surface. This technique is called "burnishing."

- Fill in the jacket lightly using Putty Beige. Use French Grey 20% to add shading under the arms, in the folds, under the collar, and between the legs.

- Using a sharpened Indigo Blue pencil, do hatching to fill in the jeans. Diagonal lines closely spaced suggest denim twill. Go lighter over the knees to give the effect of natural wear.

- With the dull indigo pencil, add shading to the jeans.

STEP 3

- Sharpening the indigo pencil again, outline the details of the jeans. Also using the indigo pencil, add details to the shoes and outline the shirt details. Sharpen it again and draw the glasses. Outline the shoes in indigo, too.

- Using the Spanish Orange pencil, add topstitching to the jeans along the seams, hem, pockets, belt loops, and fly placket details.

- Using a sharpened Black pencil, outline the figure. Use angular lines to emphasize the figure's masculinity.

- Don't complete every line to keep the drawing looking fresh, as a tightly rendered drawing can seem fussy. I've omitted some outlines and details.

- Using a ruler and the Black pencil, draw the doorway to complete the composition.

DRAFTING THE FEMALE STREET STYLE FIGURE

Street style poses can vary from extreme to subtle. This understated pose is inspired by the sophisticated déshabillé favored by editors at French *Vogue*. Fashion editors are perpetually holding a smartphone. The desired effect of this type of stance is as if the subject were caught unawares and unposed.

MATERIALS

2B pencil
Pencil sharpener
Kneaded eraser
Ruler
Translucent layout paper or tracing paper

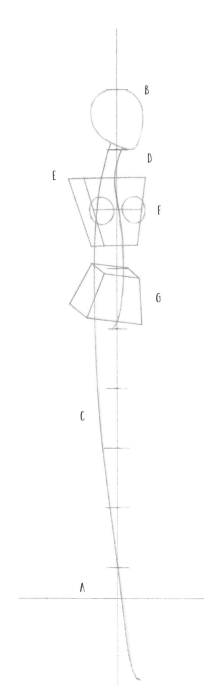

STEP 1

A Draw a vertical line down the center of the page. Mark 8" (20 cm) for the height and divide into eight equal 1" (2.5 cm) sections. Then ½" (1.3 cm) below the bottom mark, draw a horizontal line for the street.

B In the top section, draw an egg shape for the three-quarter view of the head. The pointed end is on the lower right.

C From the bottom of the head to the street, draw a sweeping, abstract gesture line. This is only subtly curved for a deliberately affect-less pose.

D From the front of the neck to the center mark, draw a line for the center front of the body. This will gently curve back at the shoulders and forward at the stomach.

E Draw a trapezoid for the top of the body, centered on the front line. The top is at the middle of the second section. The shoulders are wider than the waist. Extend the shape of the trapezoid to show the side of the three-quarter-view figure.

F Parallel to the shoulders at the third mark from the top, draw another line to guide the breasts. Along this line, draw two circles equidistant from the center front line.

G Just above the center mark, draw another trapezoid for the hips centered on the front line. This shape is tipped because the weight of the figure is on one leg. Extend the trapezoid to make a three-dimensional box.

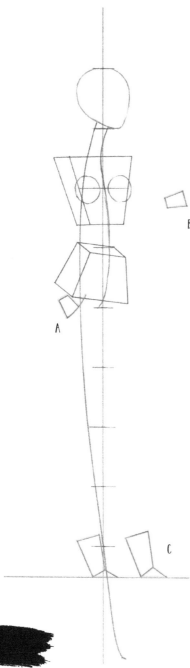

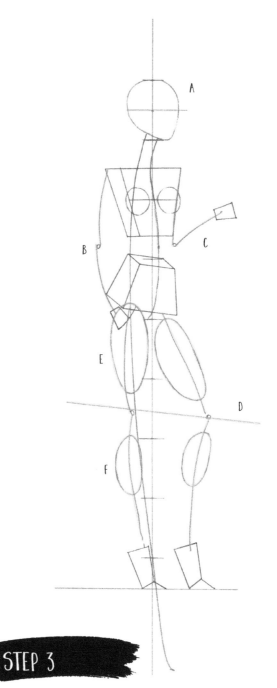

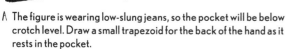

STEP 2

A The figure is wearing low-slung jeans, so the pocket will be below crotch level. Draw a small trapezoid for the back of the hand as it rests in the pocket.

B To the right of the torso, draw a shape for the hand that will be holding the smartphone.

C The toe of the weight-bearing leg is directly under the head. The shape of the high heel is a triangle with a bent end. Draw the same shape to the right for the other foot.

STEP 3

A Draw a horizontal line halfway through the head to guide eye placement.

B At the fourth mark from the top, along the center front line, mark the navel. At the same level, mark the elbows, below the shoulders.

C Connect the shoulders to the elbows and the elbows to the wrists.

D Draw a guideline parallel to the hips halfway between the hips and ankles. Mark the knees along this line. The knee on the free leg is further out because this leg is bent.

E Connect the hips to the knees and the knees to the ankles. Along the thigh lines, draw large ovals for the thighs.

F Connect the knees to the ankles. Draw smaller ovals along the lower leg lines for the calves, closer to the knees.

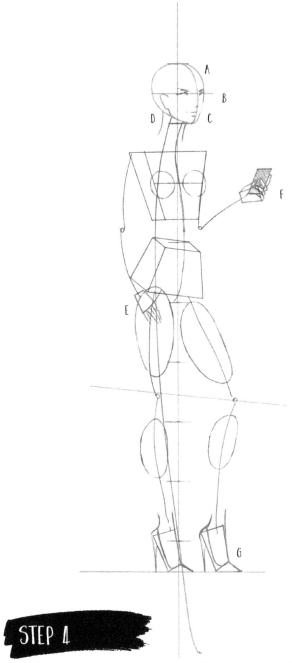

![STEP 4]

A On the right side of the head, draw a curved line for the center of the face.

B The eye on the far side appears closer to the center line because it is recessed in the face.

C Halfway between the eye line and the chin, mark the shadow under the nose. Halfway between the nose and chin, draw the mouth. Add a smaller mark just below to suggest the lower lip.

D Toward the back of the head, just under the eye line, draw a shape for the ear, and then connect the ear to the chin. Draw two lines for the neck.

E For the hand in the pocket, add the fingers, making the entire hand long enough to cover the face.

F For the hand holding the phone, draw a parallelogram for the device. To the top of the palm, add the shape for the thumb, which will be partially obscured. The fingers are tricky. I recommend using your own hand holding a phone as a reference.

G The model is wearing high pointed pumps, modified over the triangles, with sharp stilettos under the heels.

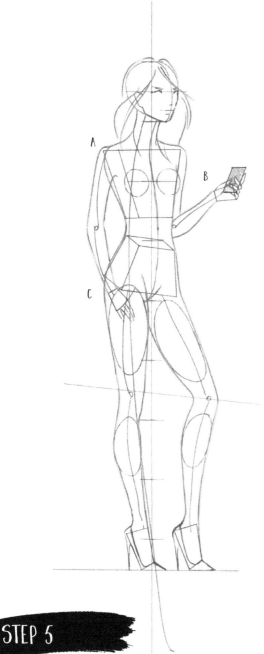

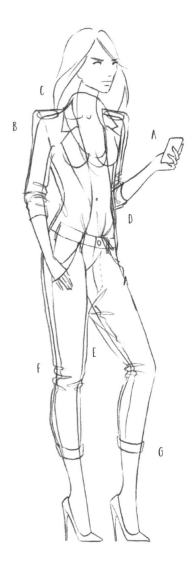

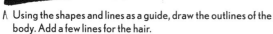

STEP 5

A Using the shapes and lines as a guide, draw the outlines of the body. Add a few lines for the hair.

B The arm holding the cell phone is partially obscured by the body.

C This figure is very thin, so the hips are narrow and the butt is flatter.

STEP 6

A Trace the contours of the body onto layout paper, eliminating the drafting lines. Omit any parts of the figure that are hidden, such as the thumb behind the phone.

B Draw small ovals over the shoulders for the shoulder pads. Dress the figure, leaving space between the body and the clothing.

C Connect the collar of the jacket behind the neck so it appears to drape naturally around the shoulders.

D The shirt is partially tucked, so the wrinkles radiate from the tuck.

E The crotch of the jeans is well below the actual crotch.

F Add wrinkles behind the knees of the jeans and at the elbows of the jacket.

G Curve the cuffs of the jacket and the jeans so they appear to wrap naturally around the limbs.

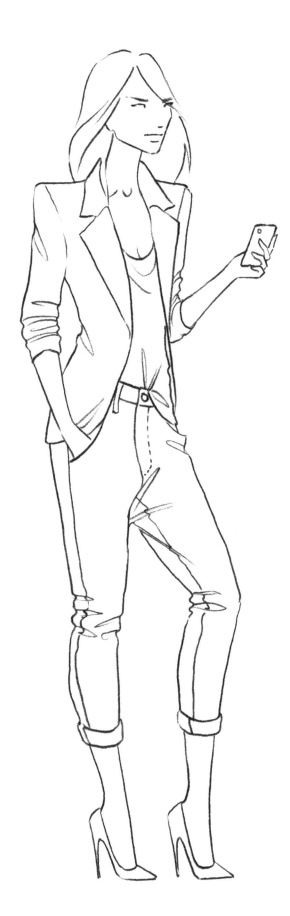

Trace the finished draft onto another
sheet of paper, eliminating the lines of the
body under the clothing.

This is the completed draft ready for the
marker rendering tutorial.

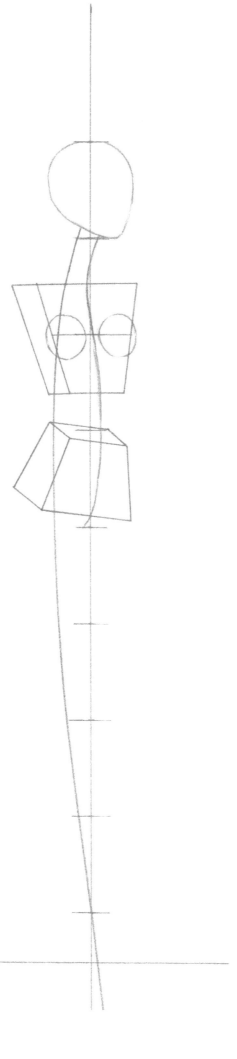

RENDERING IN MARKERS

Solvent-based art markers were widely adopted by fashion designers in the 1980s, and are still used to quickly communicate ideas. Karl Lagerfeld is often filmed using them. They're often double-ended with different widths, either wedge-shaped or brush-shaped. This tutorial will be a loose rendering, so shake out your arm and loosen up.

MATERIALS

HB pencil
Pencil sharpener
Kneaded eraser
Marker paper
Markers (I used Prismacolor Premier in the following colors):
Pale Peach, Cinnamon Toast, Mocha Light, Salmon Pink, Eggshell,
Cool Grey 30%, Brittany Blue, Indigo Blue, Cool Grey 40%
Colored pencil (white)
Fine-tipped marker (black)

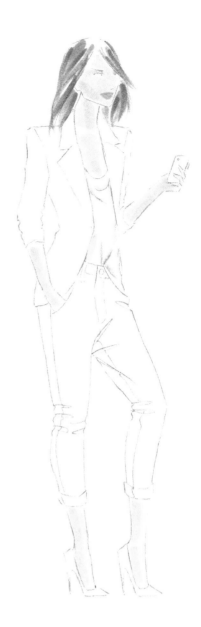

STEP 1

- Make sure your work area is well ventilated, as markers off-gas as they dry.

- Lightly trace the draft onto a sheet of marker paper. Marker paper is translucent, and treated so that the solvent will spread into the paper without leaking through the paper.

- Using quick strokes with the Pale Peach marker, fill in the arms, legs, and décolletage, jogging the marker at the collarbone. Don't worry about the lines. This is a loose rendering.

- Be more careful rendering the face. Use the narrow end of the marker and avoid going over the pencil lines so you don't smudge the graphite. Leave white space for the eyes.

- Using the Cinnamon Toast marker's brush end, do a few quick strokes for the hair. Keep it light and loose.

- Markers are a wet media, like watercolor, so you can do either wet-on-wet or wet-on-dry. For the next step, we'll do wet-on-dry. Wait to make sure the first layer is totally dry.

- Using the Mocha Light marker, add darkness to the hair, especially under the ears and chin. Leave lightness on the top of the head.

- For shading the skin, use the Pale Peach marker again. Drop a spot on the jaw for the cheekbones, another on the neck, and a dot to suggest the space between the breasts. Shade under the arms and the backs of the legs, wiggling the marker at the ankle.

- Using the narrow end of the Salmon Pink marker, fill in the lips.

- The tank under the jacket is white. Use Eggshell for the folds of the loose shirt.

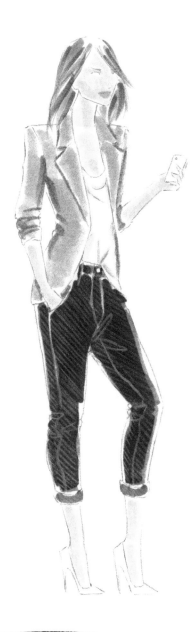

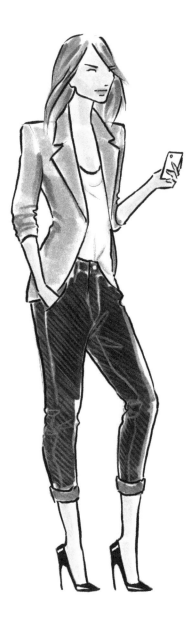

STEP 2

- Use Cool Grey 30% to fill in the jacket. Fill in each section quickly and separately. Wiggle the marker at folded sections like the elbow.

- Wet-on-wet for the jeans will create a smooth, soft quality. Use Brittany Blue first. Leave white space along the edges. Wiggle the marker at the knee folds. Immediately go over the first layer with Indigo Blue, excepting the cuffs.

- Once the jacket has dried, use Cool Grey 40% for shadows under the collar and the folds.

- On the jeans, hatch with white pencil for a twill texture. Don't be too neat—it's a loose rendering.

STEP 3

- Using a black fine-tipped marker, define the outline of the figure and the edges of the garments. Do this as quickly and accurately as you can. Don't make it too detailed—keep it loose and lively.

- When I do loose marker drawings, I do a lot of them, until I finally get one that seems spontaneous and natural, yet also beautiful.

4

ILLUSTRATING RED CARPET FASHION

The red carpet is far more influential beyond the fashion industry than either runway shows or street style. The entire world watches when celebrities arrive at glamorous events, almost always dressed and styled by professionals, looking exquisite. In this chapter, we'll draw two classic conventions of the red carpet.

For the first drawing, we'll draft a back view of a female figure wearing a sexy backless gown with a train. This view poses a few challenges, including a hand on a hip, crossed legs, and the back view of a high heel. We'll also be drafting a facial profile with Caribbean features. Then, we'll render the drawing in watercolors, exploring the possibilities of using a wet medium, resist technique, and mixing skin tones, while also touching on the concept of negative space.

The second drawing will feature two figures, as it is common for famous people to arrive on the red carpet with a date. The draft will show how to make interacting figures look believable. Rendering the final illustration in Adobe Photoshop, we'll discuss inking, scanning, and cleaning line art, making patterns and wrapping those patterns around the figure, rendering hair and makeup, and showing the difference between matte and shiny fabrics.

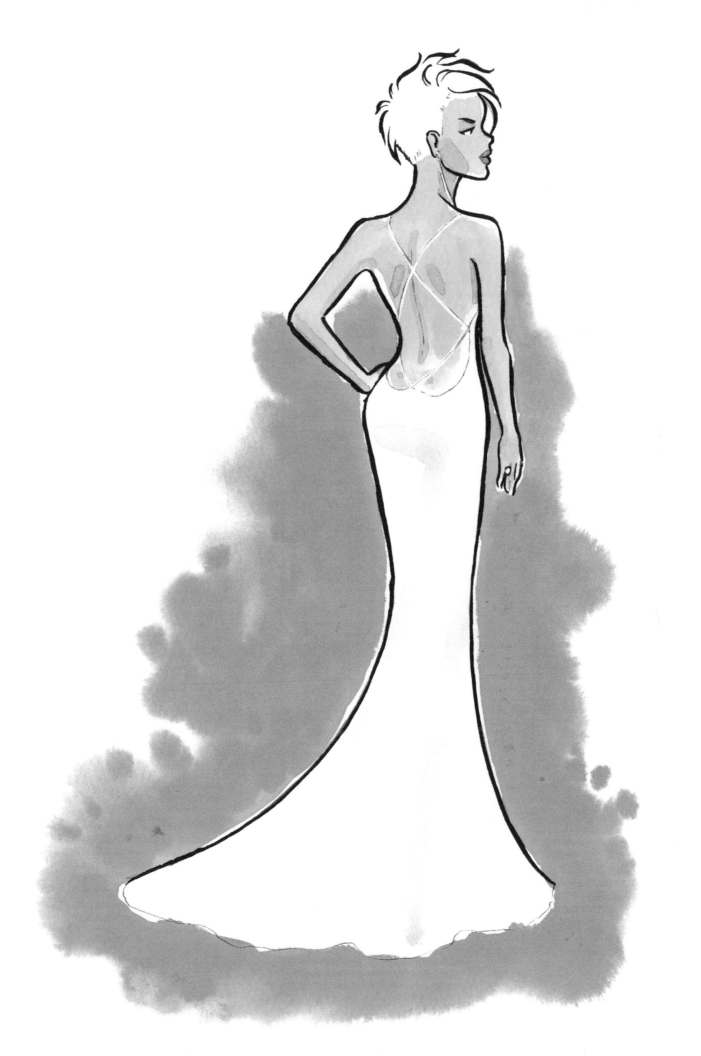

RED CARPET GESTURES

More than any other fashion arena, the red carpet highlights the disparities in traditional gender role presentation to an extreme degree. Women dress to excess, exaggerating femininity, and masculine conventions are rigid. This reflects the "black tie" dress code, which dictates precise tuxedos for men and luxurious gowns and heels for women.

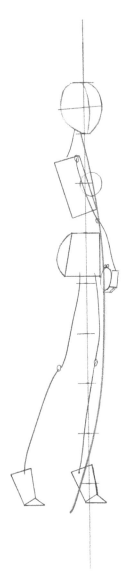

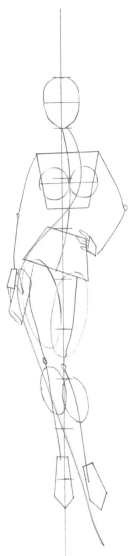

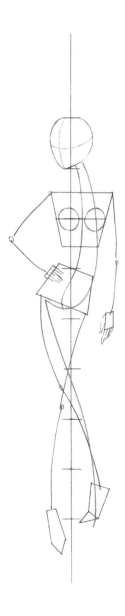

Many gowns on the red carpet are backless or feature trains, so a common pose is a side view, with the subject looking over her shoulder. The shoulder in this case is turned forward rather than back. Small clutches are the only acceptable red carpet accessory, except for an award.

The idealized body shape on the red carpet is similar to a fashion model's, though actresses and singers are often more petite. There is a second type of idealized body that is often seen on the red carpet: the hyper-feminine "hourglass" figure. Exemplified by stars like Jennifer Lopez, this ideal is full-breasted and small-waisted with generous hips. Note that the guideline for the breasts is just below the third mark from the top, because larger breasts are heavier, and there is no space between the breasts, creating cleavage.

Stars on the red carpet often have a signature pose. A great example is Victoria Beckham. Her consistent, "posh" red carpet stance is adapted from fashion models of the 1950s, with the extended front foot creating a "V" silhouette. The "turned" ankle can be traced back to Louis XIV—a centuries-old gesture of aristocratic vanity.

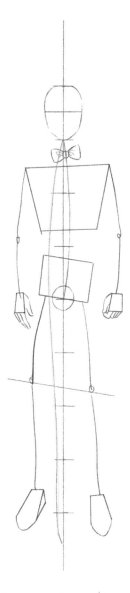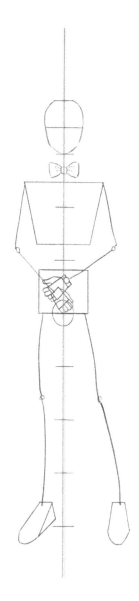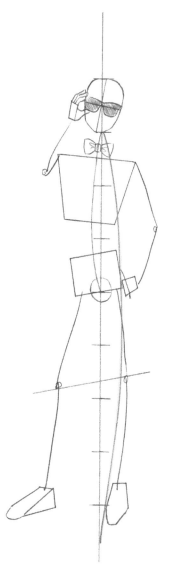

According to the traditional rules of black tie, putting your hands in your pockets is not allowed. This ancient custom, combined with the loss of cigarettes as accessory, leaves many modern men unsure of what to do with their hands, so the hands are left hanging. Often you see a male star's hands clutched in a nervous fist.

The only correct use of hands, other than holding a female date, is to be clasped, either behind (as royal men are taught to do) or in front. If in front, a man may use this gesture to feature some flash in the form of cufflinks or an expensive watch.

A rock star or a bad boy actor might attempt to subvert tradition on the red carpet by using his pockets or wearing accessories, like sunglasses. Rebellious gestures are minor and rare. Red carpet masculine hegemony dies hard.

DRAFTING THE FEMALE RED CARPET FIGURE

This is the only example of a back view in this book, and it will give you a sense of the dramatic possibilities of this angle. The major feature is, of course, the butt. Enjoy creating the sensuous curve of the spine. This draft tackles drawing a hand on a hip and making that connection believable, and the rarely attempted back view of a high heel.

MATERIALS

2B pencil
Pencil sharpener
Kneaded eraser
Ruler
Translucent layout paper or tracing paper

STEP 1

A Draw a vertical line on the right side of the page to allow space for the gown's train on the left.

B Mark the top and the bottom of the figure, 8" (20 cm) apart. Divide the height into eight 1" (2.5 cm) sections. Then ½" (1.3 cm) below the bottom mark, draw a horizontal line for the red carpet.

C In the top section, draw a circle for the side of the head, and extend a corner on the lower right for the chin.

D From the neck to the red carpet, quickly draw a gesture line to establish flow. Since this figure wears a sexy, backless gown, an S-curve has a sensual attitude.

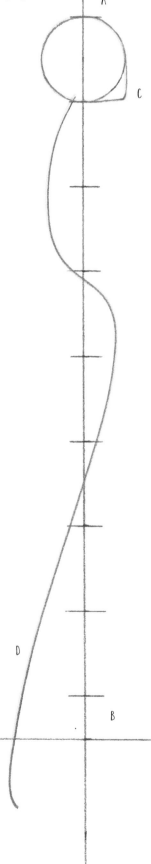

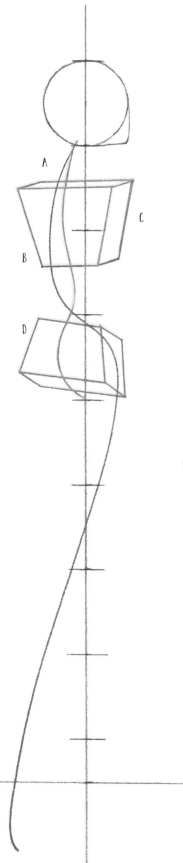

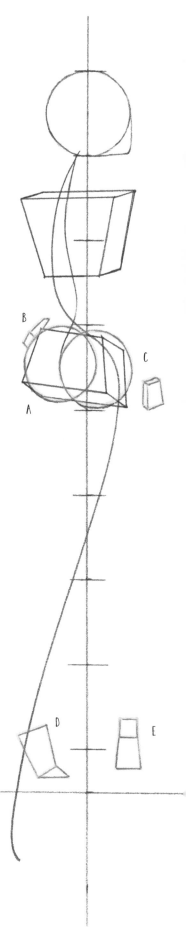

STEP 2

A From the back of the neck to the center mark, draw the backbone. The figure is wearing heels, tipping the hips and curving the spine.

B Centered at the top part of the spine, draw a trapezoid for the shoulders and ribs. The spine goes through the center of this shape.

C Extend the trapezoid shape to show the depth of the body. Since the shoulders are leaning back, the tops of the shoulders are visible.

D Just above the center mark, draw a trapezoid for the hips. Make it centered and perpendicular to the lower spine. Extend that shape to the lower right, so the side and bottom are visible.

STEP 3

A Over the hips, draw two large circles for the butt. The circles overlap outside the edges of the trapezoid.

B Draw a small rectangle placed on the hip for the hand. Drawing the hand before the arm helps it rest naturally on the figure.

C Draw the other hand below the shoulder, just to the right of the center mark.

D The legs of the figure are crossed. Draw the right foot to the left of the center line. It will be seen from the side, shaped like a triangle with a bent end. The figure is wearing platform heels, so leave space between the sole and the red carpet. The heel is level with the lowest mark.

E Draw the left foot to the right of the center line. This foot is placed higher, because the left hip is higher.

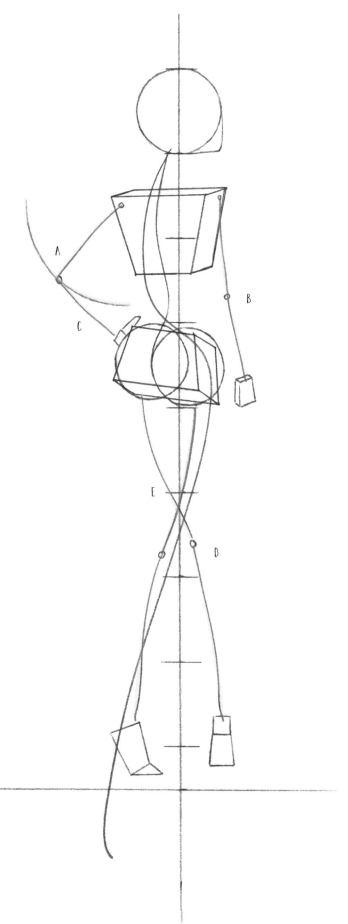

STEP 4

A Draw a curved guideline from the waist using the shoulder as an axis. Mark the elbow of the bent arm along this curve, checking that the upper and lower arm lengths are equal.

B For the other arm, mark the elbow at waist level.

C Connect the shoulders to the elbows and the elbows to the wrists.

D Mark the knees halfway between the hips and ankles. The knee of the left leg is higher because the hip is higher. Check that the thighs and calves are the same length.

E Connect the hips to the knees to the ankles, making sure the legs cross at the knees.

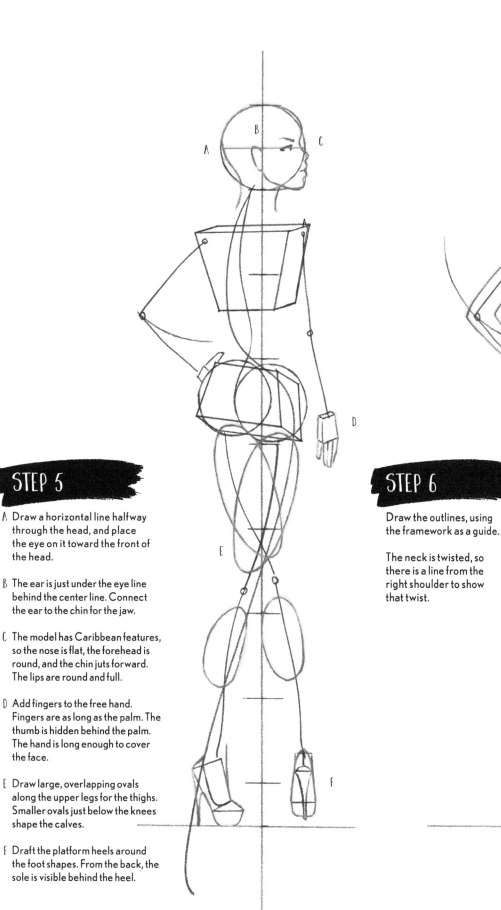

STEP 5

A Draw a horizontal line halfway through the head, and place the eye on it toward the front of the head.

B The ear is just under the eye line behind the center line. Connect the ear to the chin for the jaw.

C The model has Caribbean features, so the nose is flat, the forehead is round, and the chin juts forward. The lips are round and full.

D Add fingers to the free hand. Fingers are as long as the palm. The thumb is hidden behind the palm. The hand is long enough to cover the face.

E Draw large, overlapping ovals along the upper legs for the thighs. Smaller ovals just below the knees shape the calves.

F Draft the platform heels around the foot shapes. From the back, the sole is visible behind the heel.

STEP 6

Draw the outlines, using the framework as a guide.

The neck is twisted, so there is a line from the right shoulder to show that twist.

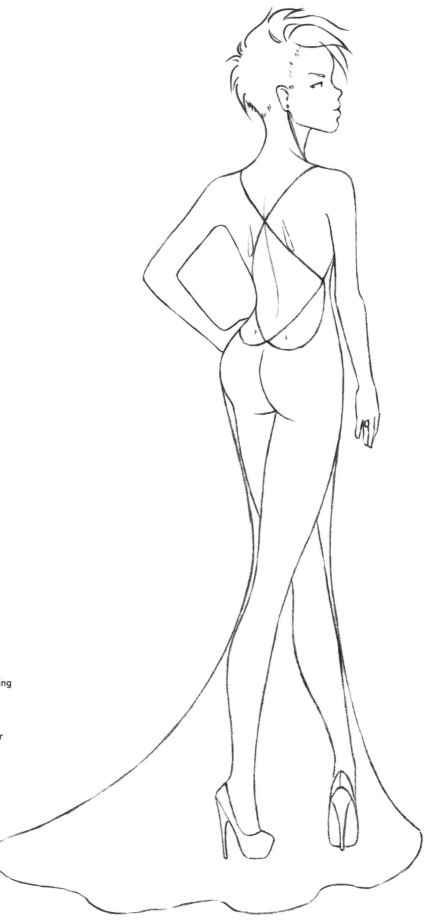

STEP 7

Trace the figure from the draft. Add hair and jewelry.

On top of the body, draft the gown, extending the train of the dress to the left of the page.

The back of the gown has a symmetrical spaghetti strap detail. The straps cross over the spine.

The draft is now ready to be rendered in watercolor.

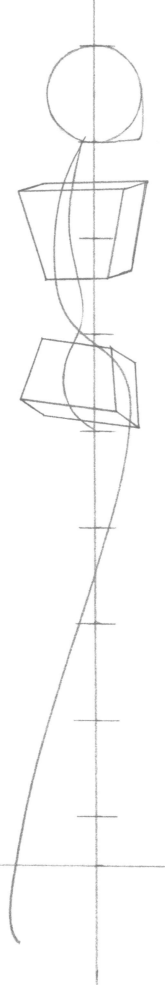

RENDERING IN WATERCOLOR

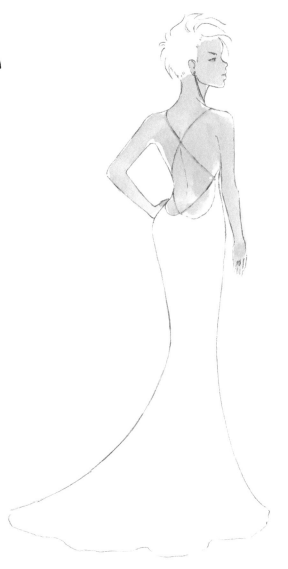

Watercolor requires strategy and a light touch. The unpredictable quality of liquid media can result in unsightly splats or serendipitous accidents. Prepare to use a lot of paper, learn to let go, and watercolor will surprise you in wonderful ways.

The "trick" of watercolor is that less is more. Leaving unpainted white space on the page will give your paintings that delicate quality that makes this medium a natural choice for beauty and fashion illustration.

MATERIALS

Light box
HB pencil
Pencil sharpener
Kneaded eraser
140lb hot press watercolor paper
Liquid frisket
Pen handle with flexible nib 33
Round sable paintbrushes in sizes 0, 4, 6
Water containers and water
Watercolor paint (I used the following colors):
Burnt Sienna, Burnt Umber, Cobalt Blue, Yellow Ochre,
Alizarin Crimson, Cadmium Red, Mars Black
Palette
Tissues
Rubber cement pickup

STEP 1

- Using a light box and a pencil, trace the draft onto watercolor paper. Hot press paper is smooth and best for fashion illustration. Buy 140lb, as the heavier weight absorbs water without buckling. Have plenty of extra paper; it's better to start over than to fix mistakes.

- Shake your liquid frisket well before using. Frisket is a resist, allowing you to leave specific areas unpainted. Using a flexible nib pen, fill in the eyes, the earrings and ring, and the straps. Wash the nib right away. Let the frisket dry totally before painting.

- Using the #4 sable round brush and water, mix the skin tone on the palette. Use diluted Burnt Sienna and Burnt Umber as a base. Add very tiny amounts of Cobalt Blue, Yellow Ochre, and Alizarin Crimson. Skin is a complex combination of many different colors because it is translucent. To warm the skin tone, add Yellow Ochre or Burnt Sienna. To cool it, add Cobalt Blue or Burnt Umber. Test your color as you go, and keep mixing until you are pleased.

- Load your brush with the color and quickly fill in the back, arms, and face of the figure. Don't be too neat; leaving white space is recommended. It's important to do it all at once, to avoid splotches.

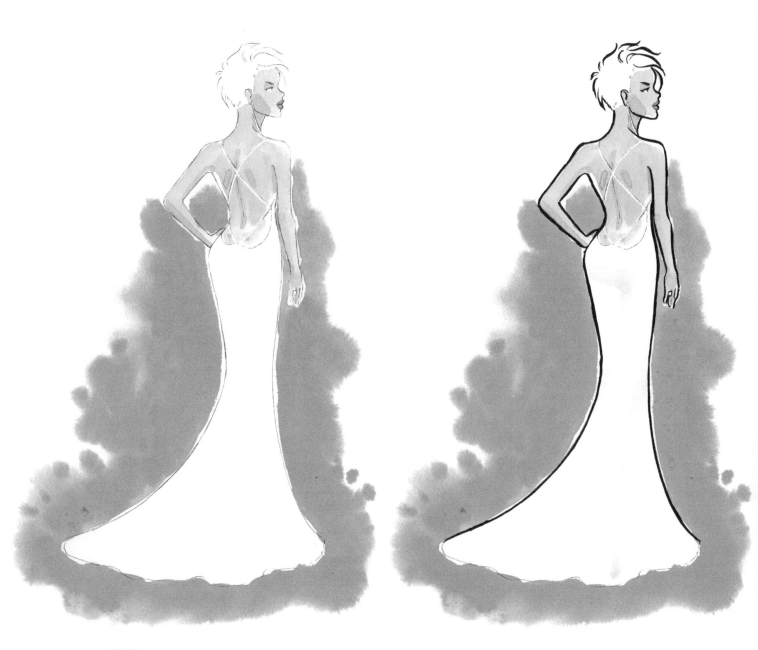

STEP 2

- Let the first layer of paint dry totally. There are two main watercolor techniques: wet-on-wet and wet-on-dry. We'll render the skin with wet-on-dry.

- Load the brush with skin tone mixture again, and brush it on wherever there are shadows. Carefully shade below the cheekbones, on the jaw, and underneath the eyebrows for eye sockets. Shade under the arms, along the spine, and below the shoulder blades.

- Clean your brush and dip it into the Alizarin Crimson for the lips. Carefully touch the brush on the upper and lower lips, and connect them at the corner of the mouth.

- If you make a mistake, quickly dab with a tissue to lift the paint away. If you wait, it soaks into the paper, and you'll have to start over.

- The red carpet will be added using the wet-on-wet technique. Load your #6 sable round brush with fresh water. Wet all around the figure. Make sure the paper is soaked, adding water until the surface glistens.

- Working quickly, load the brush with Cadmium Red and drop it onto the wet paper near the figure. You'll see the paint spread and whisker, and even swirl into puddles. Experiment with dropping on dots or strokes, or adding some Alizarin Crimson, too.

- Once you're happy with the saturation of the red carpet, leave it to dry. It will take a little while. In the meantime, carefully remove the frisket with the rubber cement pickup.

STEP 3

- Dip a wet #0 sable round brush into Mars Black. Paint the outline of the figure and the facial features. Turn the paper sometimes to make sure you can stroke the brush at a comfortable, smooth angle. Do not render every line to keep the illustration from looking overworked.

- Using the #4 sable round brush, loaded with water, pick up a tiny bit of the skin tone and add a shade and folds to the dress. This is the finished artwork.

DRAFTING A RED CARPET COUPLE

Celebrities often bring a date to red carpet events. These two figures are holding each other possessively, as if they're newly in love. Drawing two figures interacting is advanced drafting. For this complex tutorial, the male figure's progress is highlighted in pink, and the female figure's progress is blue.

MATERIALS

2B pencil
Pencil sharpener
Kneaded eraser
Ruler
Translucent layout paper or tracing paper

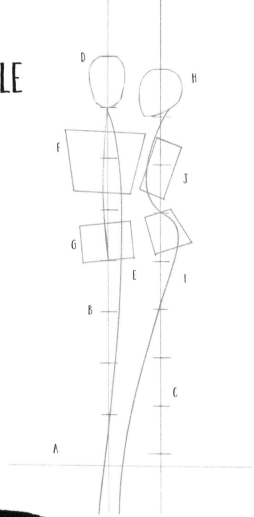

STEP 1

A Draw two vertical lines down the center of the page, 1⅛" (2.8 cm) apart. At the bottom of the page, leaving a margin below, draw a horizontal line for the red carpet.

B On the left line above the carpet, draw eight marks 1 1/16" (2.7 cm) apart, so the height of the male figure is 8½" (21.6 cm).

C On the right vertical line, mark ¼" (6 mm) above the carpet, because the female is wearing heels. Then draw eight marks 1" (2.5 cm) apart above.

D On the left line, in the top section, draw an egg shape for the male head.

E From the male head to the carpet, draw a subtly curved gesture line. From the male head to the center mark, draw a slight curve opposite to the gesture line for the spine.

F Draw a trapezoid for the male's upper body. It is perpendicular to and centered on the spine.

G Above the center mark on the male figure draw a rectangle that it is perpendicular to and centered on the lower spine, for the hips.

H On the right line in the top section, draw an egg shape for the female head. Her head is at a three-quarter view, pointed on the lower left.

I Since the female figure is hyper-feminine, draw a sensuous S-curve for the gesture line. The front torso swings toward the male figure, and the seat of the figure sways away above the center mark.

J Along the S-curve, draw two trapezoids for the female's upper and lower body from the side. Since the figure is wearing heels, the hips are angled back.

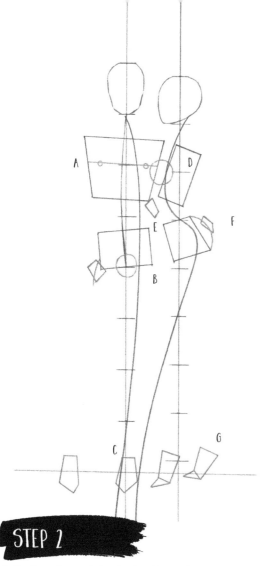

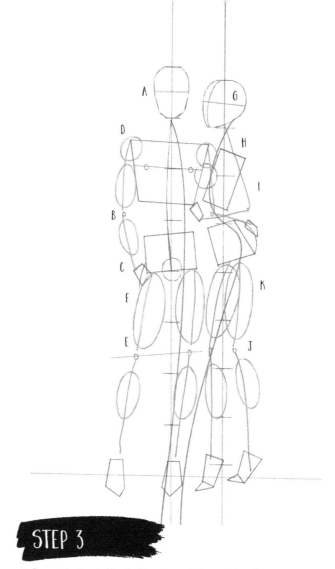

STEP 2

A On the male, parallel to the shoulders at the third mark from the top, draw a line. Along it, draw nipples equidistant from the center.

B At the center mark on the male, draw a round shape for the package. To the left, draw a vertical curve for the trousers' pocket. Over the pocket draw a trapezoid for the back of the hand.

C Along the left center line, on the carpet, draw a shape for the male's dress shoe of the weight-bearing leg, under the high hip. To the left, draw the other shoe.

D On the female figure, draw a circle for the breast on the left of the upper torso, level with the third mark from the top.

E Just under the male's torso, draw a small rectangle for the female's hand.

F On the right edge of the female's hips, draw a round curve for the butt. On top of that curve, draw a trapezoid for the back of the male's hand.

G Below the hips of the female figure, draw two bent triangles for the high heels. Make the near one lower and angled down, and the far one higher and angled up.

STEP 3

A Draw a horizontal line halfway through the male head.

B Halfway between the male's shoulder and wrist, mark the elbow. Draw another mark on the other side, behind the female body.

C Connect the male's shoulders to the elbows and the elbows to the wrists. The right forearm appears shorter because it wraps around the female figure.

D At the male figure's shoulders, draw round shapes for muscles. Along the visible arm, draw ovals for the biceps and forearm.

E Halfway between the male's hips and ankles, draw a guideline parallel with the hips. Mark the knees along this line. Connect the hips to the knees and the knees to the ankles.

F Along the male's upper legs, draw large ovals for the thighs. Along the lower legs, draw ovals for the calves.

G Halfway through the female head, draw a line angled toward the male head. Along the left side of the head, draw a curve for the center line of the face.

H Draw a line for the female's neck.

I Level to the waist, draw a mark for the female's elbow, just above the male's hand. Connect the shoulder to the elbow and the elbow to the wrist.

J Halfway between the female's hips and ankles, mark the knees. Connect the hips to the knees and the knees to the ankles.

K Along the female's upper legs, draw large ovals for the thighs. Along the lower leg lines, draw ovals for the calves.

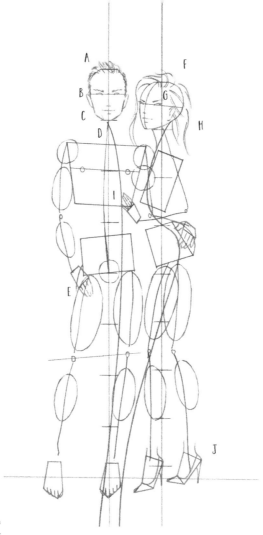

STEP 4

A On the male's head, add hair, extending it above the top of the head.

B On the male head's eye line, equidistant from the center, draw eyes with eyebrows above.

C The male's ears are under the eye line, and connected to the chin.

D Halfway between the eyes and chin, mark the nose. Halfway between the nose and the chin, draw the mouth, marking below to suggest the lower lip.

E The male's fingers are as long as the back of the hand. The fingers on the hand holding the female figure curve around her, and the thumb appears shorter.

F On the female's head, add a dramatic sweep of hair, flowing up from the forehead and back above the ear.

G Draw eyes along the female's eye line. The far eye appears closer to the center line than the near eye. Halfway between the eyes and the chin, along the center line, mark the nose. Halfway between the nose and the chin, draw a line for the mouth, with a mark below suggesting the lower lip.

H Below the eye line, toward the back of the head, draw the ear, and connect it to the chin.

I Add fingers to the hand resting on the male figure's chest. The fingers are as long as the back of the hand.

J Over the triangle shapes representing the female's feet, draw the heels. On the male's feet, add toes.

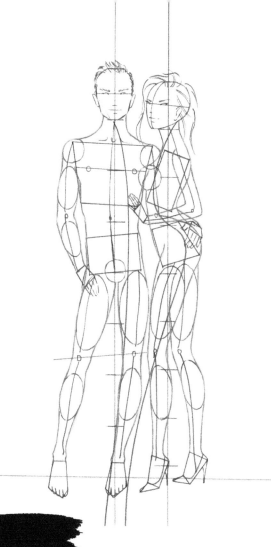

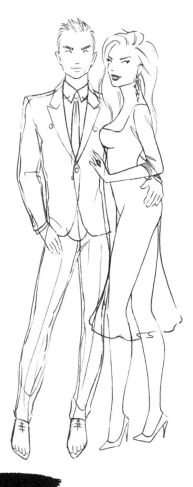

STEP 5

Using the frameworks of shapes and lines as a guide, draw the outlines of the figures. For the male, use firm, straight strokes, and for the female, use graceful curves.

Don't draw the male figure's other arm behind the female; only part of the forearm will be visible.

STEP 6

Take a piece of tracing or layout paper and trace the figures, eliminating all of the drafting framework.

Over the top of the figures, draw the clothing. Add space over the male's shoulders for the suit's padding. The tie and button align with the center front of the male body.

The female's dress is body-conscious and skintight. Add folds at the inside of the bent elbow. Add earrings and a ring on her finger.

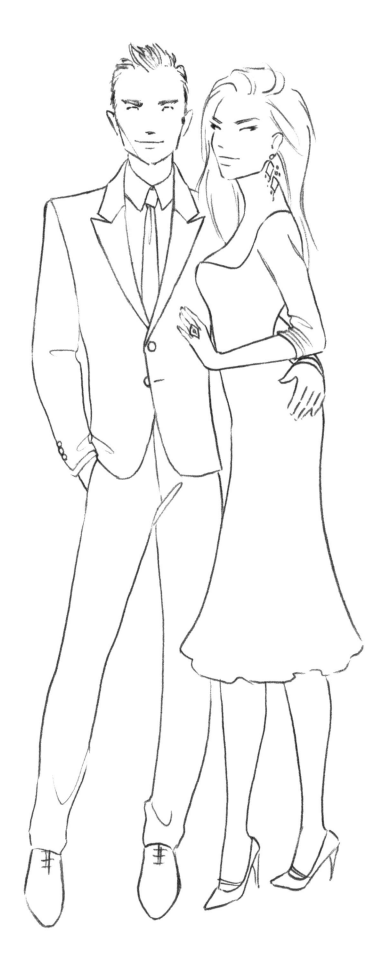

Take another piece of layout or tracing paper and trace the final draft, eliminating parts of the bodies concealed by clothing.

Parts of the male figure are hidden behind the female figure.

This is the finished draft, ready for the ink and Adobe Photoshop rendering tutorial.

RENDERING IN ADOBE PHOTOSHOP

Adobe Photoshop is industry-standard software used by image makers worldwide. It's a complex, powerful tool. Having used it for over a decade, I'm still discovering new ways to do things.

When I make paper dolls, I draw the outlines in ink, scan the images, and then color in Photoshop using a tablet and stylus. This section will cover how to render faces, hair, shading, and highlights; create a repeating pattern; and wrap a pattern around a figure.

Photoshop is available on a monthly subscription, and a free trial is available, too. Check the Adobe website for details.

MATERIALS

Art pens in sizes 01, 03, 05
Translucent layout paper
Window cleaner
Cotton cloth or paper towel

EQUIPMENT

Scanner
Computer with Adobe Photoshop installed
Tablet and stylus
Digital camera

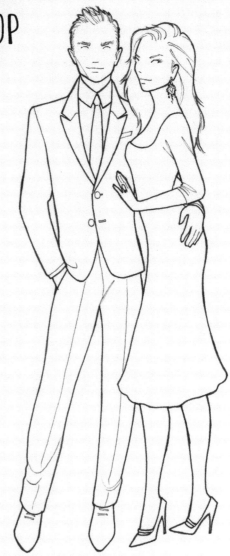

Fig. A

STEP 1: INKING

• With the 01 pen, trace the draft (fig. A). When inking two figures, get the faces right first, and then render less critical parts of the figures. You can "fix" small mistakes in Photoshop; however, analog line quality can't be matched digitally, so focus on getting it right in the inking stage.

• With the 03 pen, add definition to the garments, such as the cuffs of the pants, or folds like the collar. Also distinguish parts of the body like hands and jawlines. With the 05 pen, outline around both figures to make them stand out.

STEP 2: SCANNING

• Clean the glass surface of the scanner with window cleaner and a cotton cloth or paper towel.

• Scan the image. Make sure the media setting is on "Color" to pick up maximum information. For clear printing, the scan should be 300 dpi or higher. Photoshop is a "bitmap" program. Bitmap images are constructed from many tiny squares called pixels. Use JPG, a bitmap format.

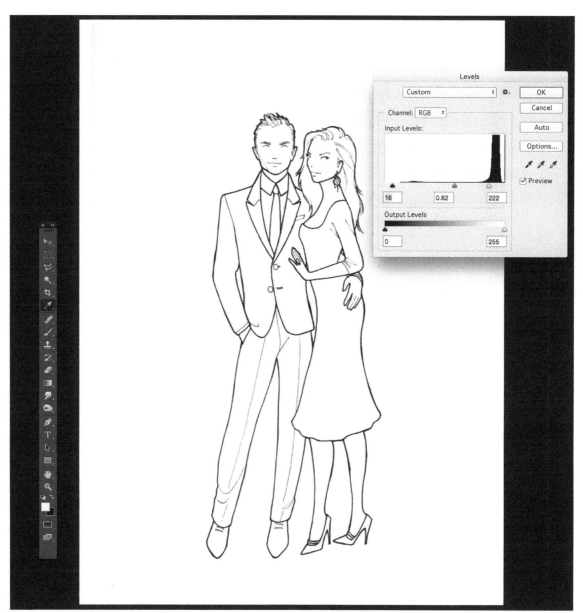

Fig. B

STEP 3: SETTING UP YOUR TOOLS IN PHOTOSHOP

- When you open up your scanned JPG in Photoshop, organize the tools you'll be using. At the top of the screen, choose the drop-down menu "Window." Here you can toggle the visibility of various tools.

- Make sure that the Brush, Color, History, and Layers tools are checked, so they're visible. Click and drag the windows to whatever position you prefer.

STEP 4: EDITING THE LINE ART

- Click the "Image" drop-down menu, open the sub-menu "Adjustments," and select the option "Levels," or Image > Adjustments > Level (fig. B).

- The Levels window shows a "histogram" visualizing the tonal range of the image. There are three sliders to adjust black, mid-tones, and white. Move the white slider left, just past the highest peak of the histogram. This makes the background white.

- Move the mid-tone and black sliders right, to darken the inked lines. Leave some gray in the image to soften the lines.

Fig. C

STEP 5: CLEANING UP THE BACKGROUND

- Remove scanner shadow and any dust or smudges around the figures using the Polygon Lasso, the third tool down on the tool menu.

- With Polygon Lasso selected, click points around the figures as if cutting the figures out of paper. Click where you started to close the lasso.

- On the top menu, choose Select > Inverse. Then choose Edit > Fill and fill with white.

STEP 6: USING BRUSHES FOR EDITING LINE ART

- Select the Brush tool from the toolbox. Options are above the workspace. Click on Size and Shape (a spot with a number) to adjust the settings. Make "Hardness" 100 percent. If your tablet has the capability, many brush tips will be pressure-sensitive.

- At the bottom of the toolbox, there are two small swatches of color representing foreground and background. Switch the top swatch to white or black depending on whether you're building up a line or making it finer.

STEP 7: TIDYING UP

- Here's a zoomed-in detail of unedited line art next to edited line art (fig. C). I've tidied up the lines of the hair and smoothed the female cheekbone. I've whitened gray areas. I've left some of the rough quality of the inking in, too. Remember, no one else will look at the image at 600 percent. Check which lines need adjustment at 100 percent. Anything that doesn't register at 1:1 won't be worth fixing.

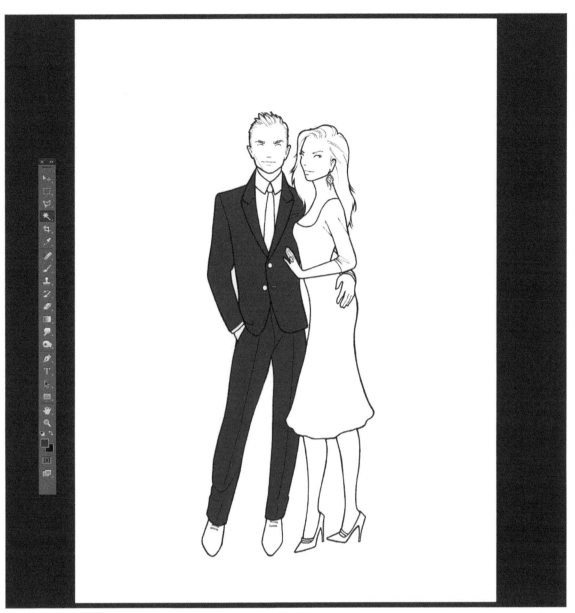

Fig. D

STEP 8: COLORING SOLID GARMENTS

• On the Layer window, click the small icon that looks like a piece of folded paper to create a new layer. Select that layer and click on the menu that says "Normal" to choose a blending mode. For a transparency effect, select "Multiply."

• Click on the "Background" layer to work on the line art.

• Select the Magic Wand tool from the toolbox on the left. Settings are above the workspace. Tolerance determines what will be selected. Low tolerance (0) only selects pixels of a single color. Higher tolerance (in this case, 33) also selects pixels close to the selected color. Make sure Contiguous is checked, so Magic Wand only selects an isolated area of white background contained by black lines, rather than all the white areas.

• Use Magic Wand to click on a sleeve of the jacket. Holding the Shift key, click on a lapel to add that selection, too. Continue shift-clicking until the suit is entirely selected. At the top menu, choose Select > Modify > Expand. Expand the selection by two pixels so the color will overlap the line art.

• Select Layer 1, in Multiply mode. Using the Color window in the right sidebar, select a color for the suit. I've chosen navy blue. Click on Edit > Fill and fill the suit with the Foreground Color.

• On the keyboard, click Command-D (or Ctrl-D) to deselect. The suit is fully colored now (fig. D).

• Use the same technique to fill in the shirt with dark gray, the tie with dark blue, the brogues with burgundy, and the pumps with dark red.

Fig. E

Fig. F

STEP 9: RENDERING A PATTERNED GARMENT

- On the Layers window, click the icon that looks like folded paper to create a new layer. Click and hold the name "Layer 2" to change it to "Pattern."

- To make a floral pattern, use photographs of flowers. I suggest shooting your own. Photography is useful for capturing textures and patterns to collage into your digital artwork.

- Download flower photos from your camera and open them up in Photoshop.

- With a flower file selected, use the Polygon Lasso tool and tap around the shapes of the flowers to separate them from the background. Hold the Shift key when clicking to add to the selection, and hold the Alt key when clicking to subtract from the selection.

- With a flower selected, choose the Move tool (at the top of the toolbox) and drag the flower from the photograph to the illustration file. Repeat these steps for all the floral photographs.

- Rename the new layers "flower 1," and so on .

- Select the "Pattern" layer again. Use the rectangle Selection tool to draw a rectangle. In the Color window, select a cream color for the base of the pattern. Choose Edit > Fill to fill with the foreground color (fig. E).

- Zoom in over the rectangle to make the floral arrangement of your repeating pattern. Duplicate flowers by clicking and dragging flower layers to the "New Layer" icon (fig. F).

- Change the scale and rotation of the flowers by selecting a layer and clicking Edit > Transform. To change the size, click on one of the corner handles of the transformation box, hold down the Shift key to maintain the aspect ratio, and drag diagonally. To rotate, float the cursor by the corner handle of the transformation box, and a small bent arrow appears. Click, hold, and rotate.

- If any flowers are over the edge of the rectangle, use the rectangular Selection tool to select the part of the flower that's over the edge. With the Move tool selected, use the arrow keys on the keyboard to move that flower part to the opposite side of the pattern.

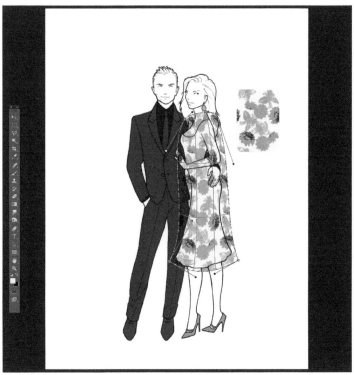

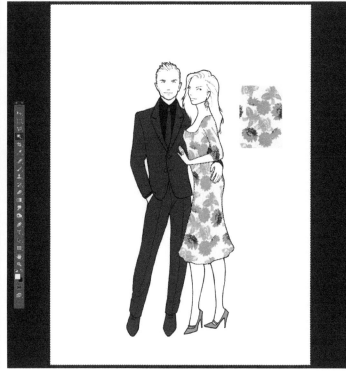

Fig. G

Fig. H

• Once all the flowers are inside the box, select all the pattern and flower layers by shift-clicking them in the Layer window. Then click the tiny menu icon on the top right of the Layer window and "Merge Layers," so the pattern is on a single layer.

• Select outside the pattern using the Magic Wand tool, and then Select > Inverse. With the pattern selected, go to menu Edit > Define Pattern and name it "floral."

• Create a new layer called "dress," with the blending mode Multiply.

• On the dress layer, using the rectangular Selection tool, draw a rectangle over the female figure's dress. Go to the menu Edit > Fill and choose "Pattern" from the menu. Under Options choose the Custom Pattern "floral." This will tile the pattern we created, so it repeats.

• Go to the menu Edit > Transform > Warp. This will allow you to warp and "wrap" the pattern around the dress. Move the handles and the sections of the transformation box to adjust the pattern to the dress (fig. G).

• Click on any tool in the menu and a pop-up box will ask if you want to apply the transformation. Click Apply!

• On the Background layer, use the Magic Wand tool, with Contiguous selected, to select the dress. With the entire dress selected, choose the menu Select > Modify and expand the selection. Then choose Select > Inverse.

• Select the dress layer and press the Delete key. This deletes the pattern outside of the dress (fig. H).

• Deselect by pressing Command+D. Now the dress is patterned; well done!

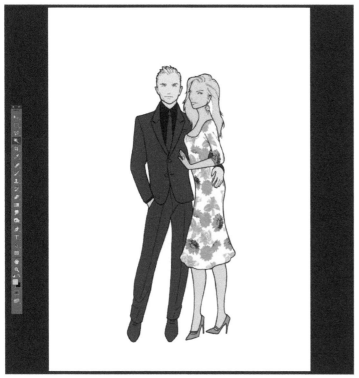

Fig. I

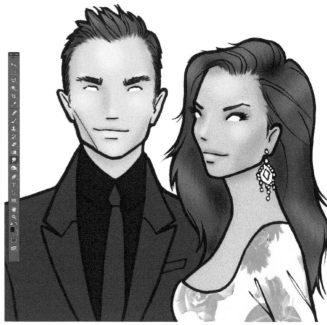

Fig. J

STEP 10: RENDERING SKIN AND HAIR

• On your illustration file, create a new layer called "skin and hair" and set the blending mode to Multiply.

• Pick the Magic Wand tool with Contiguous checked. Working on the Background layer, click one of the legs of the female figure with your magic wand. Holding down the Shift key, click all the other parts of the female figure's skin. Then go to the menu Select > Modify > Expand and expand the selection.

• Open a photo reference for the female's skin color. Using the Eyedropper tool, click on a mid-range value of skin tone. The Eyedropper will make it the new foreground color.

• On the illustration file, select the "skin and hair" layer and select Edit > Fill to fill with the foreground color.

• Repeat the process for the male's skin tone, using another reference image (fig. I).

• Zoom in close to the heads using the Magnifying Glass tool at the bottom of the toolbox.

• Open the skin and hair references again and use the Eyedropper tool to pick the color of the male figure's hair. On the illustration file, with the "skin and hair" layer selected, use the Brush tool to manually fill in the hair. Repeat the process for the female figure.

• Select peachy pink for the lips and rouge. Color the lips. Make the brush bigger; adjust the opacity to 50 percent and Hardness to 0 percent. Apply blush. Make the brush smaller, restore opacity to 100 percent, and use a dark brown for eye shadow.

• Select the Smudge tool from the toolbox. Settings are above the workspace. Make Strength 50 percent and Hardness 0 percent. Use a smaller size to smudge between the hairlines and the foreheads of the faces, in the direction of hair growth (fig. J).

• Select the Burn tool from the toolbox. It's like a little fist. It darkens colors. Make the Hardness 0 percent and the Strength 15 percent. Adjust the size depending on the area you're shading.

• Click on the Burn tool in the toolbox to see the Dodge tool, which looks like a lollipop. It lightens colors. Set it at 15 percent Strength and 0 percent Hardness. Adjust the size depending on the area you're highlighting.

• Select the Smudge tool again and draw it through the hair in the direction of the hair growth to give the effect of individual strands.

Fig. K

STEP 11: COMPLETING THE ILLUSTRATION

• To add a satiny sheen to the tie, select the tie using the Magic Wand tool on the Background layer. Choose Select > Modify and expand the selection. Now select Layer 1 (fig. K).

• With the Brush tool set at 50 percent Opacity and 0 percent Hardness, draw highlights on the tie. Using the Smudge tool, jog the highlights to suggest satin.

• Zoom out and use the Dodge and Burn tools on the "skin and hair" layer to add highlights and shading to the bodies.

• Working on the "dress" layer and "Layer 1," add shading and highlights to the shoes and garments of the figures using Dodge and Burn.

• This is the finished digital artwork (fig. L). Select File > Save to keep your work!

Fig. L

5

CAPTURING STYLE IN THE WILD: LIVE RUNWAY SKETCHING

The custom of sketching live at fashion shows is almost as old as fashion shows themselves, which emerged in the form we recognize them at the beginning of the twentieth century. Over the years, a few fashion illustrators have made a reputation for themselves as runway artists, most notably Kenneth Paul Block, Joe Eula, Gladys Perint Palmer, and Richard Haines.

I started sketching at fashion shows in 2007. When I started, I was usually the only one doing it, except for the occasional reporter I noticed making doodles in his or her notes.

As I write this, live runway sketching has become a phenomenon. I've noticed a lot of emerging illustrators taking it up and even established professionals like Bil Donovan trying their hand at it. Perhaps because of the ubiquity of photography, there is a very real curiosity about alternative ways of seeing fashion, and social media has fostered an interest in drawing as a performance. It's now very trendy to see artists sketching guests at fashion parties, too.

The development of the skill of live sketching is a labor of love. Although it looks quick and effortless, it took eight years of practice to develop my current technique and build the confidence necessary to have a signature style and honest gestures. All of this was absolutely worth it, as I believe sketching at international fashion shows has given me a uniquely physical, instinctive sense of contemporary fashion. It has also significantly improved my studio work.

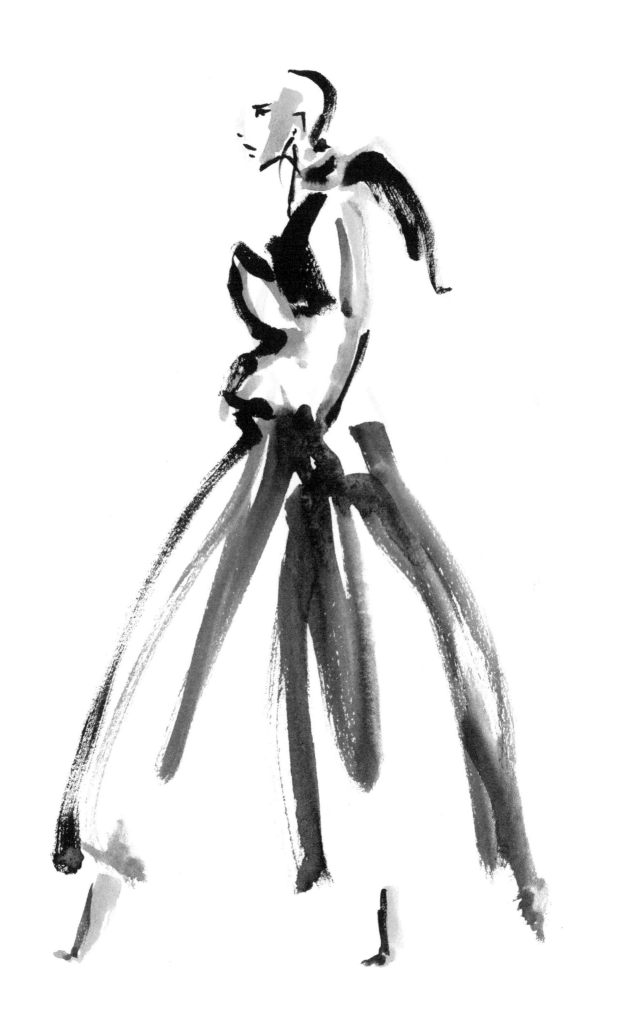

LIVE SKETCHING: THE KIT

Different artists use different mediums for live sketching. Markers are common. So are pencil crayons or watercolor pencils. I've seen some very intrepid artists use bottles of ink! My first few seasons I used soft pencils in a small sketchbook while I worked on my ability to edit my lines to the simplest essentials. It's a good idea to start using basic materials.

My watercolor palette (above) and the tote I made for live sketching (right).

Example: My Kit

- **Watercolor field kit** This is a small metal or plastic box usually with a set of small "half pans" of dry watercolor paints. There's a palette to mix paints on the inside of the lid. You can buy a kit with a preselected palette, or you can buy an empty box and create a customized palette. My current palette allows me to mix a wide range of bright colors and a wide range of neutrals plus all the skin and hair tones. Every season I adjust the palette as I observe which pans get used up and which pans remain full. As pans empty, they can be replaced, or refilled with tubes of watercolor paint.

- **Brushes and pens** A water brush pen has a synthetic brush tip and a refillable handle that holds water. Brush pens have ink in them. Pentel makes good ones, very black, with refills. White water-based markers are ideal for adding highlights. Gold and silver pens with felt tips are good for adding embellishments.

Other Stuff

- **Bag with a hard back surface** I sewed my own custom version that has a plexiglass window on one side so I can also display my work.

- **Clipboard** If your bag doesn't have a hard-back surface.

- **Paper** I recommend 140 lb. hot-press, which has a smooth surface and a nice weight. Buy, and use, lots of paper. Paper is not the place to practice economy.

- **Tissues, napkins, or cotton balls** For soaking up excess water.

- **Shirt or jacket with multiple pockets** I roll up the sleeves and stick extra tissues in the cuffs.

- **iPad or other tablet** When I don't have a seat I sketch on my iPad because watercolor requires two hands while my paper rests on my lap. (See "Touchscreens for Live Sketching," page 124.)

Some of my earliest live scribbles from Toronto Fashion Week, 2007.

Attending fashion week events provide the opportunity to sketch both models in designer clothing and the fashionable attendees.

There are four major fashion capitals—New York, London, Milan, and Paris—where the international ready-to-wear fashion month takes place twice a year, usually in February and September. On top of that, there are the inter-season resort and pre-collections, menswear weeks, and of course, the Haute Couture shows in Paris.

You can't buy tickets to industry fashion shows, which are traditionally invitation only. The audiences of these shows are selected by the public relations team of the designer to optimize the designer's reputation. Attendees are selected for three reasons: media, to promote the show; retailers, to buy the collection; and celebrities, to add prestige to the brand. If you don't fit into any of these categories, you must request tickets by contacting the designer's publicists and justifying your presence. If you're lucky, you'll receive an invitation.

In the Venue

When attending a show to sketch, I like to show up early so I can select my position strategically. If I have a seated ticket, I'll take my seat. If the view isn't good from my seat, I'll try to find a place to stand or a bit of floor to sit on. Always be nice to PR people and security guards—if they like you, you'll get a better place.

If you have a standing ticket, try to stand by an aisle, as just before the show starts the PR people will quickly fill any empty seats with whoever happens to be standing by. You might get lucky.

Since your gestures come from inside of you, it's worth being mindful of your physical, mental, and emotional condition before a show. Let go of any anxieties or fears and open up your senses.

During the Show

At the beginning of the show, closely observe the hair and makeup and the gait of the models. This will allow you to quickly draft a figure that could stand for any model. Get into the music that the designer has selected. This will help you capture the mood.

When choosing an outfit to sketch, keep in mind draped or graphic styles translate very easily to live sketching, but patterns and multiple colors slow you down.

If the sketch doesn't work out, never try to fix it. Abandon it and move on to a new one the second you screw up. See how many you can do, and maybe one will be good.

Honor your impulses. If a particular model seems like a muse, draw that model. Hold out for something to catch your eye. True inspiration makes live runway sketching magical. With practice you'll be able to enter an uninhibited state of flow, a concentrated form of creative energy that will unleash your artistry.

LIVE RUNWAY SKETCH: MALE, FRONT VIEW

This live sketch is inspired by HOOD BY AIR's androgynous Spring 2015 collection, which is why this figure seems both masculine and feminine.

 If you don't have access to a live fashion show, work from video rather than still photos to access movement and attitude. Listen to music to help you feel the atmosphere of the show.

MATERIALS

9"x 12" (23 x 30.5 cm) 140 lb hot press watercolor paper
Watercolor field kit (see page 114)
2 brush pens with water in a squeezable handle
Brush pen with black ink (optional)
Tissues for blotting

STEP 1

If you feel a spontaneous desire to draw something, go for it. Allow your enthusiasm to guide you.

As the model is coming toward you, draft the figure with a light color. Do a quick circle for the head and a swoop for the spine. Draw a line for the angle of the shoulders and a line for the angle of the hips. Do quick strokes for the weight-bearing leg and the free leg.

You'll recognize this as an abbreviated draft, collapsing the steps we learned in the drafting chapters into a few swipes.

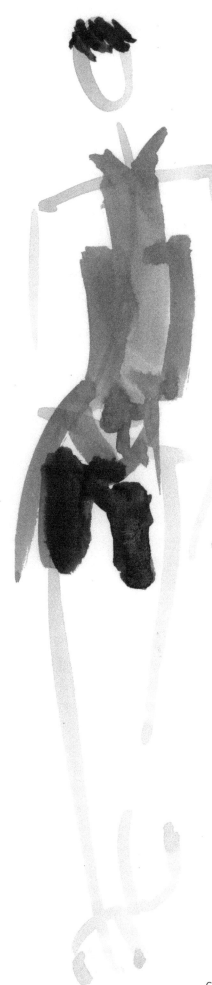

STEP 2

Now drop in the color. Don't be precious about this step—or any step in live sketching. Just lay it on there, roughly in the position that it needs to be.

STEP 3

With the framework and the color in place, there should be just enough guidance for adding the linear elements.

Using black paint or an ink brush pen, start with the eyes, leading you to the nose and mouth. Add a jawline and ears, and define details of the outfit—collar, belt, and straps. Disregard anything that doesn't have visual importance.

Since everything is loosely rendered, don't overwork anything. Don't draw both sides of a limb, for example.

The biggest challenge of live sketching is to let go when you're done. As soon as you feel you've captured the essence of the subject, lift your brush.

LIVE RUNWAY SKETCH: FEMALE, SIDE VIEW

This live sketch is loosely inspired by the Céline Spring 2015 runway show. The Céline look, as imagined by designer Phoebe Philo, combines Parisian chic with British youth subculture influences. The result is a subtle androgynous tension beloved by fashion editors.

MATERIALS

9" x 12" (23 cm x 30.5 cm) 140 lb hot-press watercolor paper
Watercolor field kit (see page 114)
Two water brush pens
Brush pen with black ink (optional)
Tissues for blotting

STEP 1

When selecting a model to draw, choosing a simple outfit will increase your chances of achieving a successful sketch.

As the model walks by, draft the figure using a light color. A light brown wash evokes skin tone. Paint an egg shape for the head, a swish for the spine crossed with a line for the shoulders. Do a long swipe for the front leg.

Drop another line from the shoulder for the arm. The model is holding a clutch handbag, so the other egg shape is the bag. This is a simplified draft.

Dip your water brush into red paint and paint the shoe.

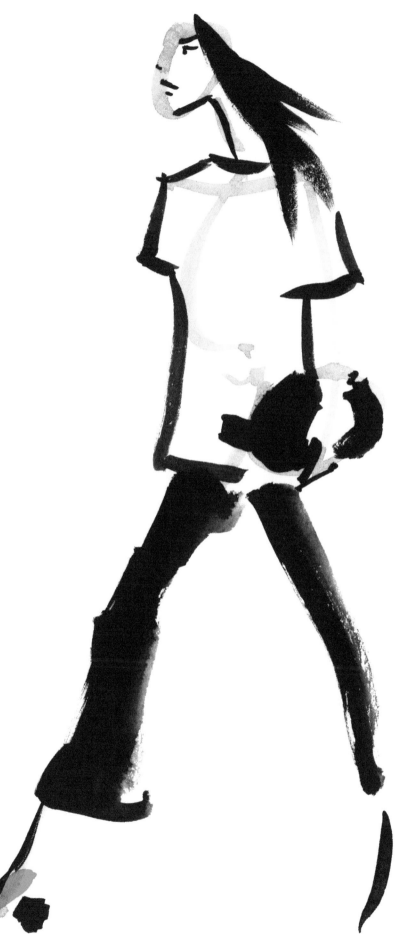

STEP 2

Load the brush with black paint. I start with the mouth: a line for the upper lip and a mark below for the shadow under the lower lip. I make another mark for the shadow under the nose. This leads me to the placement of the eye and eyebrow.

Some illustrators prefer to start with the eye. The goal is to develop the skill to draft the face in your imagination. Repeat the process of drawing a face many times until you can draw a simple face—like a dancer does a pirouette.

Do very quick swipes for the hair and outfit. I messed up the clutch here—I wish the stroke was more purposeful—but there is no time for regrets. Keep going. Accidents are part of the process.

Reload your brush with black and draw the front leg of the pants. Loosely render the shoe and suggest the back leg and foot.

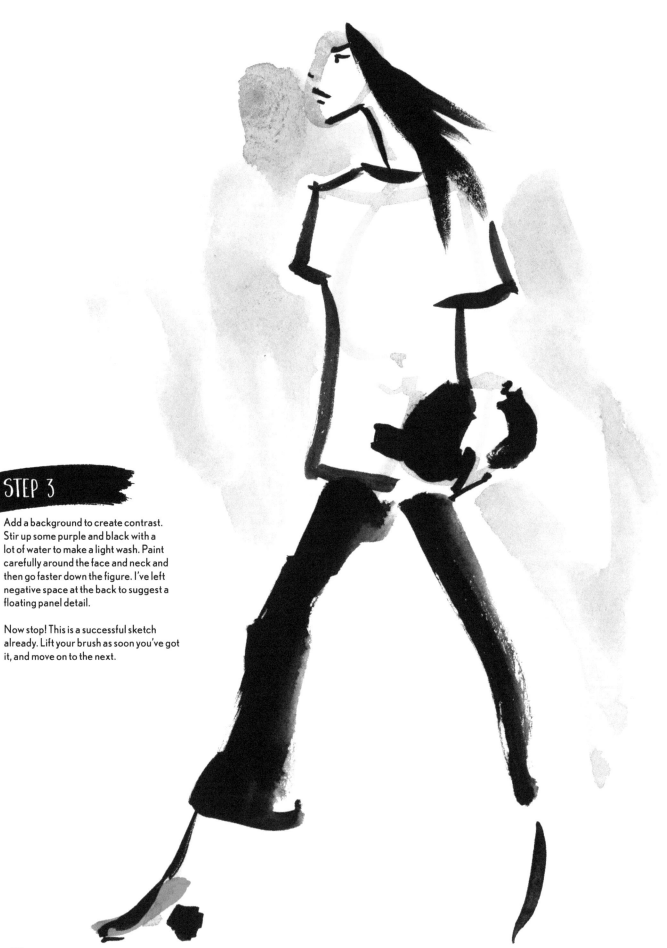

STEP 3

Add a background to create contrast. Stir up some purple and black with a lot of water to make a light wash. Paint carefully around the face and neck and then go faster down the figure. I've left negative space at the back to suggest a floating panel detail.

Now stop! This is a successful sketch already. Lift your brush as soon you've got it, and move on to the next.

TOUCHSCREENS FOR LIVE RUNWAY SKETCHING

Sketching the Diane von Furstenberg Fall 2013 runway show on the iPad.

photo credit: FiftyThree and Paper

A Very Brief History of Live Runway Sketching with Touchscreens

In 2007, Apple released the first mass consumer touchscreen product—the iPhone. A larger touchscreen tablet, the iPad, was introduced in 2010. In 2012, a company called FiftyThree launched a drawing application for the iPad called Paper.

In February 2013, I was coming to New York to attend fashion week. FiftyThree wanted someone to demonstrate how the iPad could be used to draw runway shows, and they hired me. I had never used a touchscreen before, and I had one day to familiarize myself with the iPad and the application. My first touchscreen portfolio was printed in *Women's Wear Daily*, the same paper that once employed the greatest live runway sketcher of the last century, Kenneth Paul Block. This was a tremendous experience to participate in a significant historical moment for fashion illustration. To get in on the ground floor of the future of drawing is really exciting. It's also challenging, because the technology is still in its infancy.

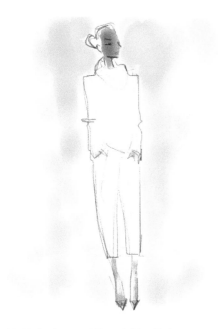
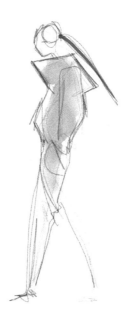
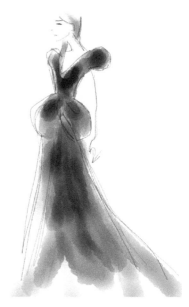

Highlights from my *Women's Wear Daily* on Paper Portfolio from the Fall 2013 season in New York. Sketches from J. Crew, Alexander Wang, and Oscar de la Renta.

Since that first exciting season, I've continued to use the iPad and Paper at every fashion week I've attended. Notice a remarkable difference in the sketches I did in London and Paris for the Fall 2015 season, shown at the top of page 125. This is because the software is constantly being updated with new tools and features.

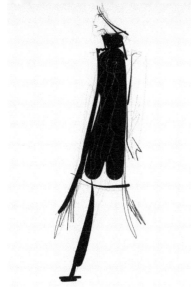

Tablets and Applications

There is now a wide range of touchscreen tablets available, and an even wider range of drawing applications. While I am loyal to iPad and Paper and find it the most elegant system, I have also used other tablets and programs. As I write, the iPad Pro with a fine-tipped stylus is being launched by Apple. This new product offers significant improvements in accuracy and sensitivity that makes it a better tool for artists.

As an application, Paper is very user-friendly, with a visual, intuitive interface. The simplicity allows it to be responsive. It's great for live sketching because it doesn't lag.

Another application, ProCreate, is targeted to artists. It allows for layered files, has a vast array of tools, and has a full range of adjustable settings. This type of program is not as suitable for drawing quickly.

Styli and Gestures

Touchscreens were developed to be used with fingertips. The capacitive screen reacts to the electrical charge within the body. While finger-painting is an option, most of us prefer to use a drawing tool. Styli for touchscreens have a rubber tip that's the size of a fingertip. This makes drawing small details difficult, because the tip obscures what you're drawing.

There is a newer type of touchscreen stylus with a narrow tip. The conductivity is produced within the hardware of the device, which is battery-intensive but allows greater accuracy.

One of the major limitations of touchscreen drawing is the absence of pressure sensitivity. Many application developers have mitigated the absence of pressure sensitivity by offering speed sensitivity. Slow strokes produce a thin line, while quick strokes produce a thick line. Newer styli allow for pressure sensitivity with compatible applications.

Tips for Live Runway Sketching on Touchscreens

The most exciting option that touchscreens offer for live sketching is the ability to draw on any color of background using a variety of tools. It's like carrying an art supply store in your hands!

The most crucial consideration for sketching quickly on the touchscreen is the judicious use of the undo option. You can find yourself undoing and redoing a single line, lost in a loop of perfectionism, while the fashion show runs away without you.

The challenge is to be mindful of this trap in order to avoid it. Viewers of illustration are drawn to the evidence of a human hand. By honoring your natural, idiosyncratic gestures, your touchscreen drawings will vibrate with personality. So don't undo, do.

Sketches on Paper by FiftyThree from the Fall 2015 season in London and Paris. Sketches from Pringle of Scotland, Bora Aksu, and A.F. Vandevorst.

Paper by FiftyThree interface, with a sketch from Baja East SS16.

6

PAPER DOLLS AND COLORING BOOK

As a special bonus, I've created a modern version of two beloved throw-back toys, the paper doll and the coloring book, with clothing inspired by critically acclaimed twenty-first-century designers. Half of the dolls and several items of clothing are fully colored, while the remaining garments are line art only, offering you the opportunity to practice rendering fabrics. I would recommend using colored pencils, watercolors, or markers. Make sure to cut the pages out of the book first and color on top of a scrap piece of paper so the markers or paint won't bleed through to the page underneath. Let dry, then carefully cut around the outlines of the dolls and garments using tiny, pointed scissors. Don't cut off the tabs, which are for holding the garments to the dolls.

Play, display, and enjoy!

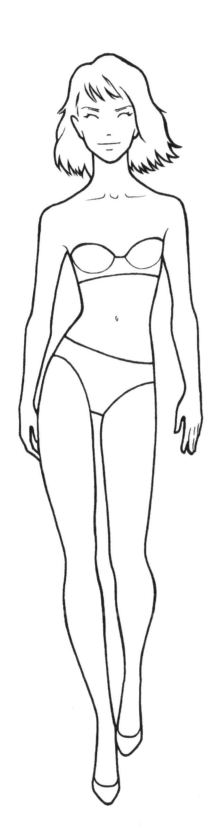
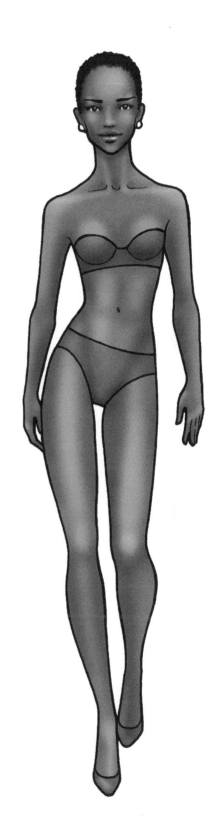

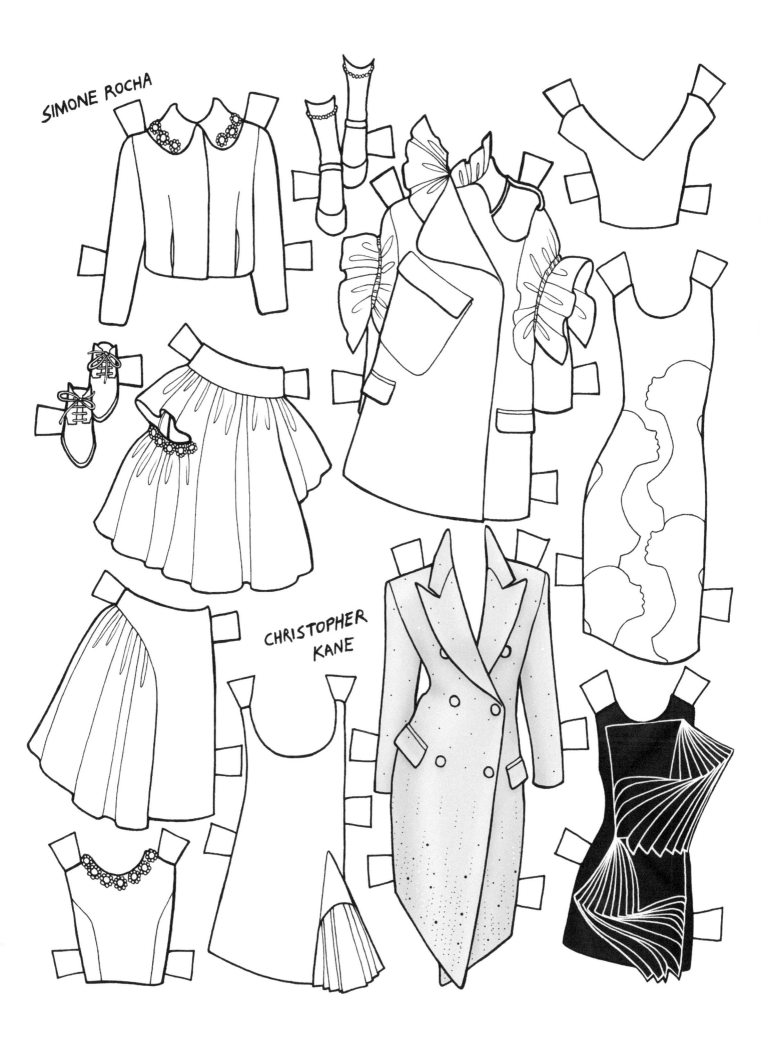

SIMONE ROCHA

CHRISTOPHER
KANE

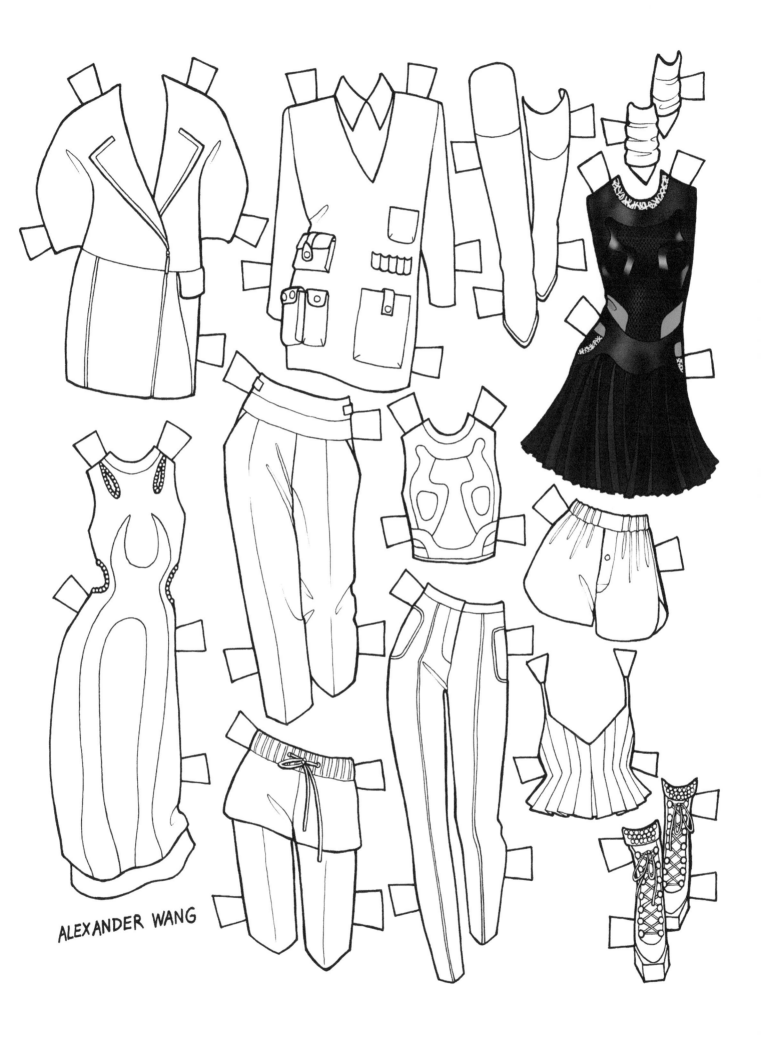

ALEXANDER WANG

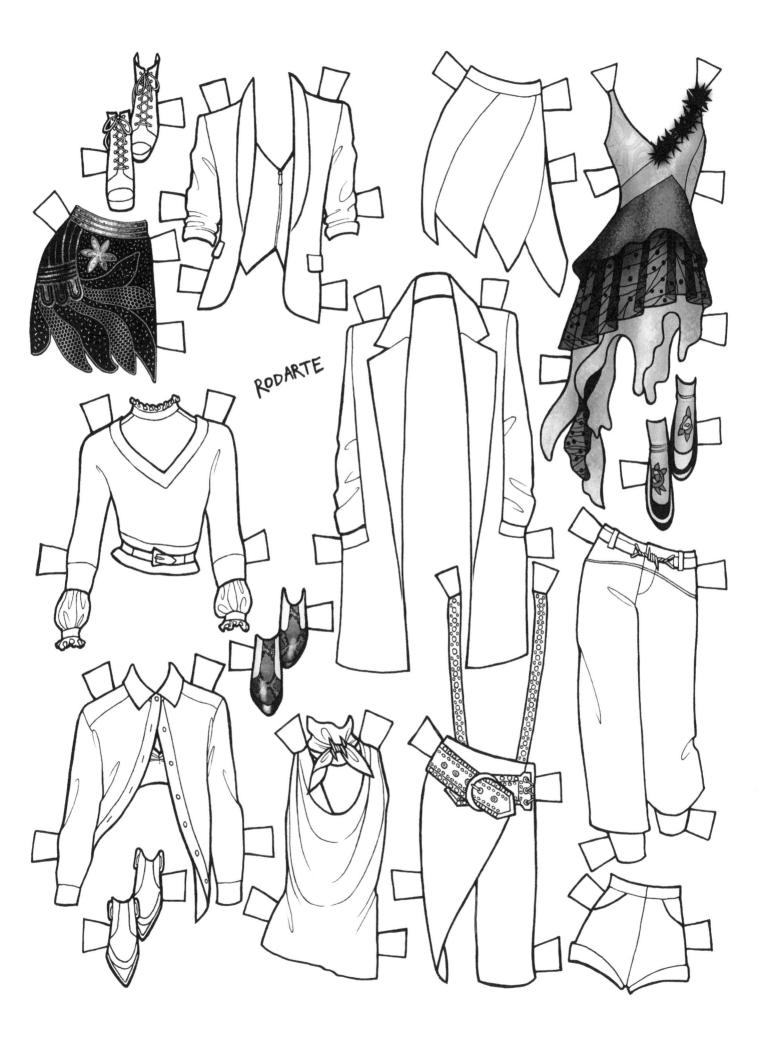

RODARTE

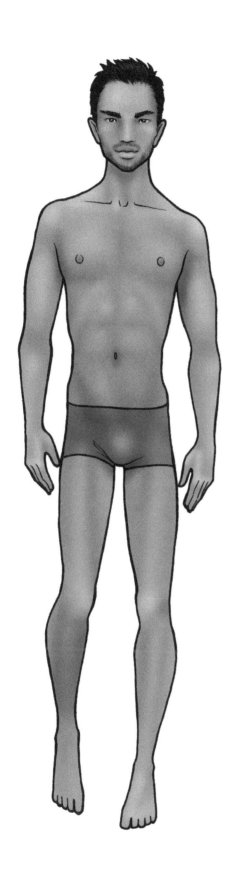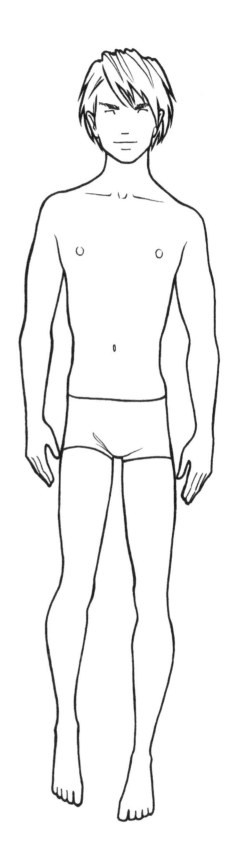

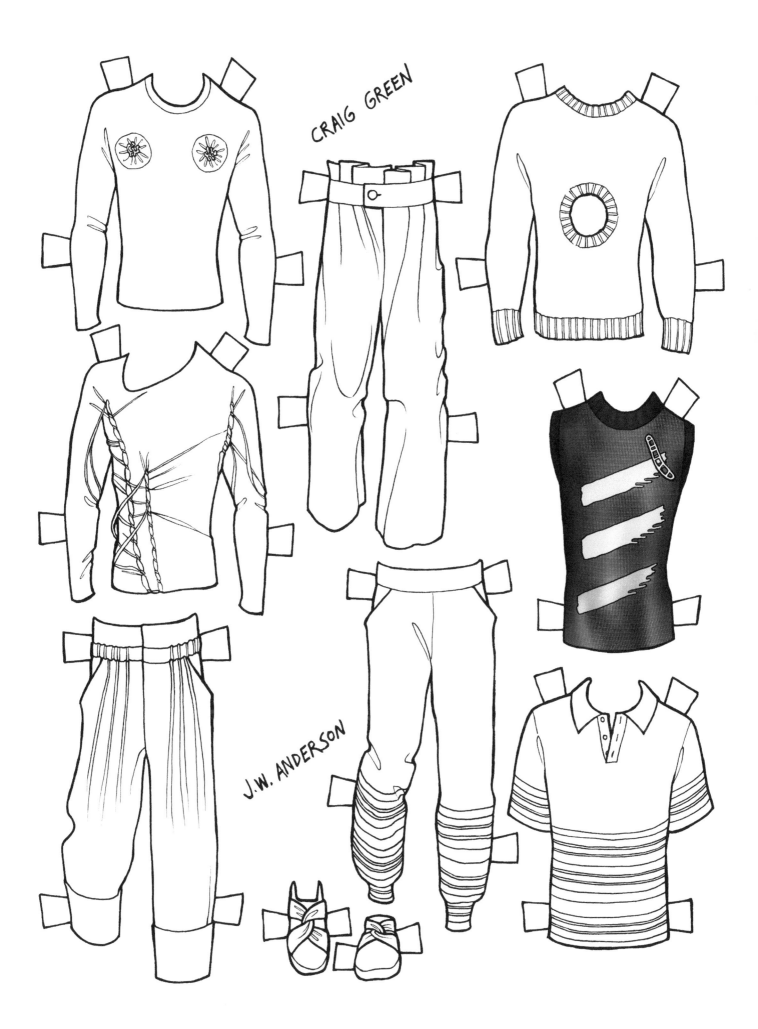

CRAIG GREEN

J.W. ANDERSON

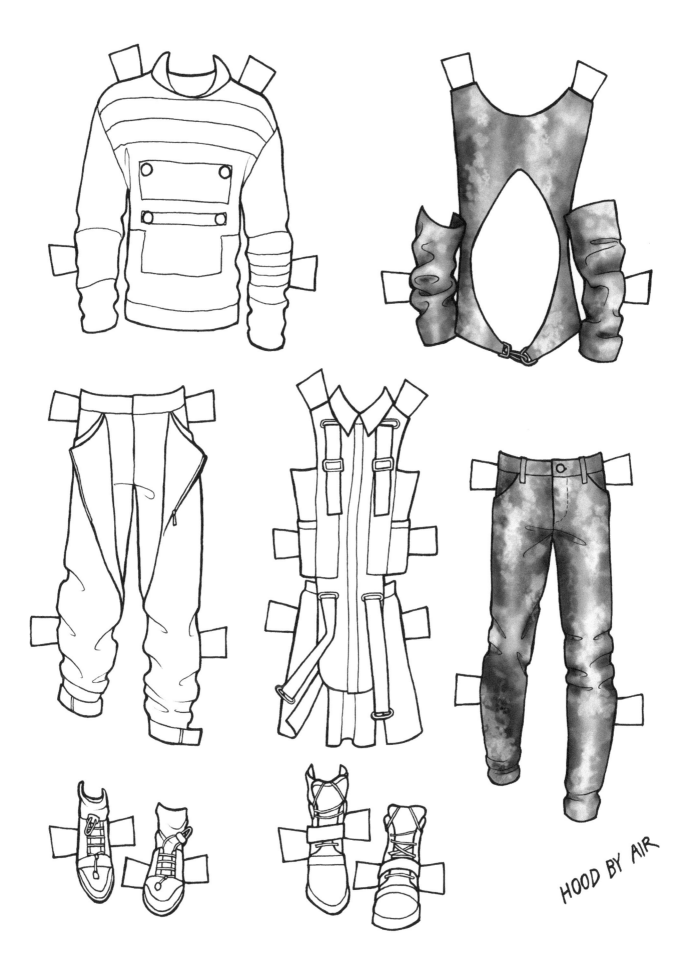

HOOD BY AIR

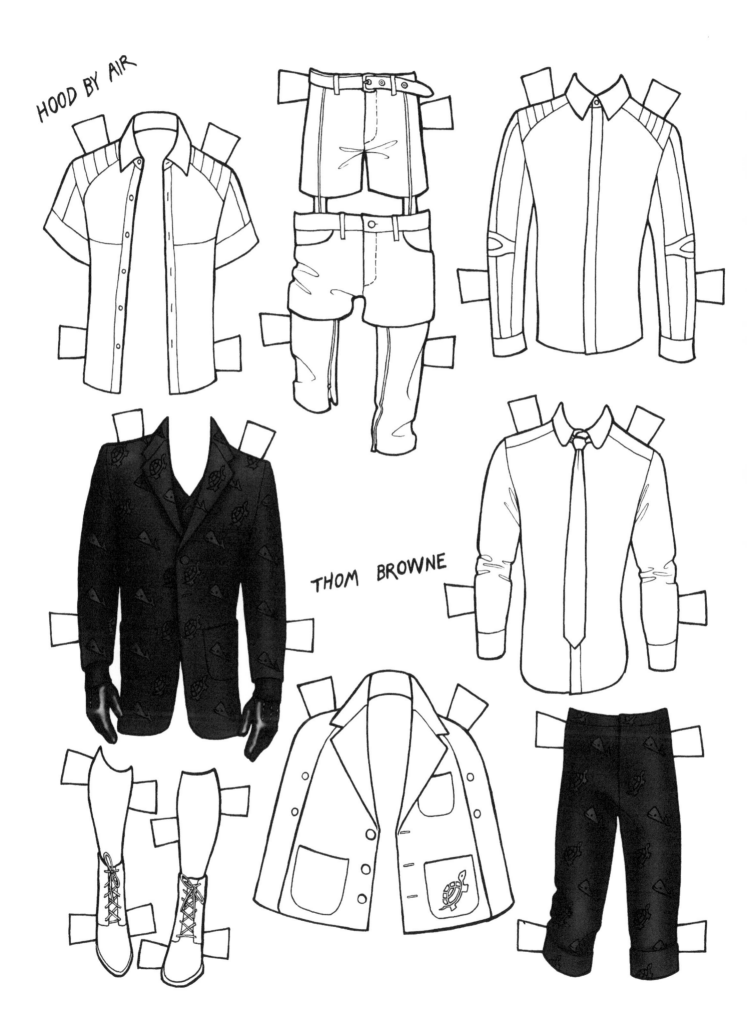

HOOD BY AIR

THOM BROWNE

RESOURCES

Abling, Bina. *Fashion Rendering with Color*. Prentice Hall, 2000.

Abling, Bina. *Fashion Sketchbook*, 4th edition. Fairchild, 2008.

Donovan, Bil. *Advanced Fashion Drawing: Lifestyle Illustration*. Laurence King, 2010.

Horyn, Cathy. *Joe Eula: Master of Twentieth-Century Fashion Illustration*. HarperCollins, 2014.

Lee, Stan. *How to Draw Comics the Marvel Way*. Touchstone, 1984.

Stipelman, Steven. *Illustrating Fashion: Concept to Creation*. Fairchild, 2010.

ABOUT THE AUTHOR

photo credit: Jonathan Daniel Pryce

Danielle Meder is an international fashion artist. She live sketches runway shows at fashion weeks in New York, London, and Paris. Her commercial clients include Bloomingdale's, *New York Magazine*, Holt Renfrew, and The Hudson's Bay Company. Her work has been featured in *Women's Wear Daily* and the *New York Times*. She is a regular contributor to the Canadian national newspaper *The Globe and Mail*. She is also a speaker and teacher, and has performed lectures and live sketching at the Apple Store and Parsons The New School.

Danielle was raised on a farm in rural Ontario, in a log home her father built. As a child she was homeschooled by her mother, who is a music teacher. She attended fashion design school at Ryerson University in Toronto, graduating with honors in 2006. She began her career as a freelance illustrator while she was still a student and continues to be independent.

She now spends her time in her four favorite cities: Paris, Toronto, London, and New York.

ALSO AVAILABLE

Dream, Draw, Design My Fashion
978-1-63159-097-9

20 Ways to Draw a Dress
978-1-59253-885-0

Brimming with creative inspiration, how-to projects, and useful information to enrich your everyday life, Quarto Knows is a favorite destination for those pursuing their interests and passions. Visit our site and dig deeper with our books into your area of interest: Quarto Creates, Quarto Cooks, Quarto Homes, Quarto Lives, Quarto Drives, Quarto Explores, Quarto Gifts, or Quarto Kids.

© 2016 Quarto Publishing Group USA Inc.
Text and illustrations© 2016 Danielle Meder

First published in the United States of America in 2016 by
Rockport Publishers, an imprint of The Quarto Group,
100 Cummings Center, Suite 265-D, Beverly, MA 01915, USA.
T (978) 282-9590 F (978) 283-2742 QuartoKnows.com

Rockport Publishers titles are also available at discount for retail, wholesale, promotional, and bulk purchase. For details, contact the Special Sales Manager by email at specialsales@quarto.com or by mail at The Quarto Group, Attn: Special Sales Manager, 401 Second Avenue North, Suite 310, Minneapolis, MN 55401, USA.

ISBN: 978-1-63159-120-4

Digital edition published in 2016
eISBN: 978-1-63159-187-7

Design and Page Layout: Think Studio | thinkstudionyc.com
Cover Image: Danielle Meder
Photography and Illustrations: Danielle Meder, unless noted.